# Winter Wonderland
## in Yellowstone

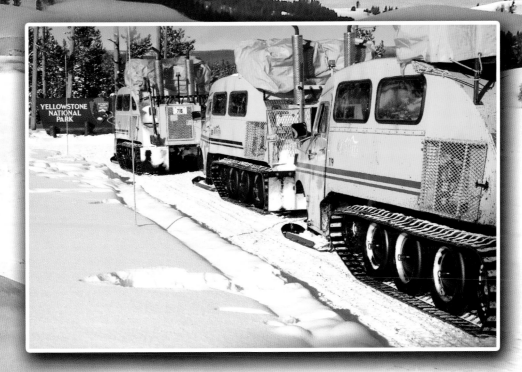

**photography and text by I-Ting Chiang**

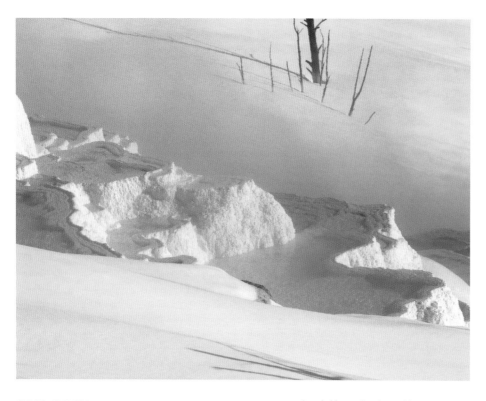

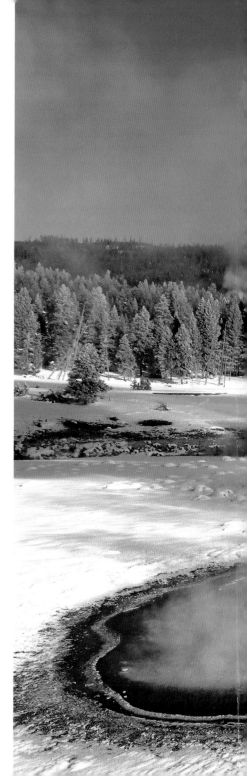

ISBN: 978-1-59152-223-2

For more information or to order extra copies of this book call Farcountry Press toll free at (800) 821-3874.

sweetgrassbooks
a division of Farcountry Press

Produced by Sweetgrass Books, PO Box 5630, Helena, MT 59604; (800) 821-3874; www.sweetgrassbooks.com

The views expressed by the author/publisher in this book do not necessarily represent the views of, nor should be attributed to, Sweetgrass Books. Sweetgrass Books is not responsible for the content of the author/publisher's work.

Produced in the United States of America.
Printed in China

22 21 20 19 18     1 2 3 4 5

**Above:** Lovely blue water rimmed by travertine rock.

**Right:** The coexistence of snow and steamy Crested Pool showcases the signature winter scenery in Yellowstone.

**Title page, background:** In winter, Hayden Valley becomes a remote corner to reach in the park. The immense valley floor is ringed by forested ridges and mountain ranges.

**Title page, inset:** A fleet of Bombardier snowcoaches sits at Yellowstone's South Entrance.

**Front cover:** Upper Geyser Basin in winter.

**Back cover:** Runoff from Sapphire Pool in Biscuit Geyser Basin.

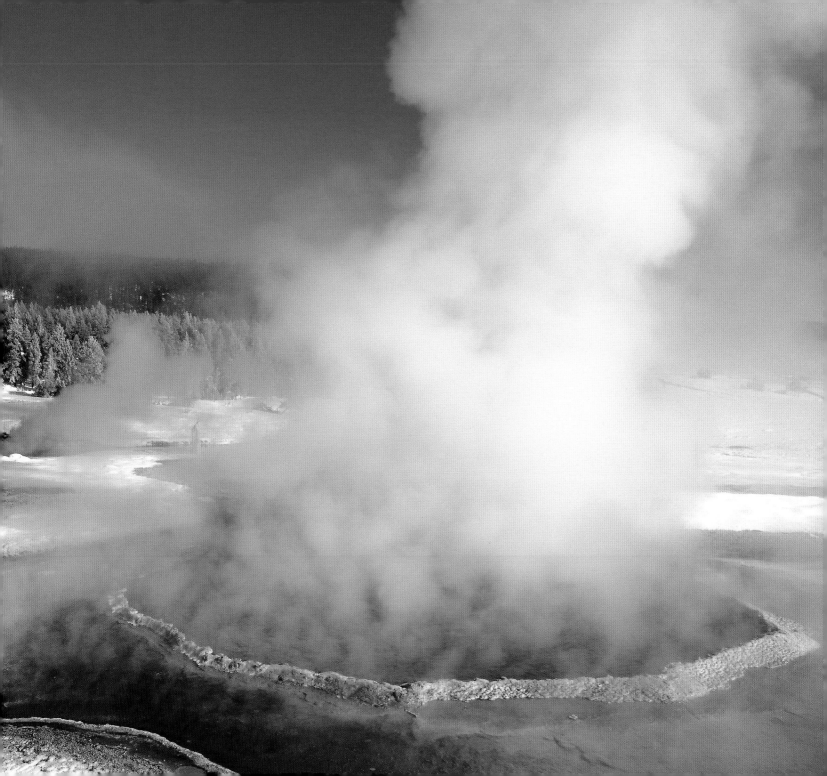

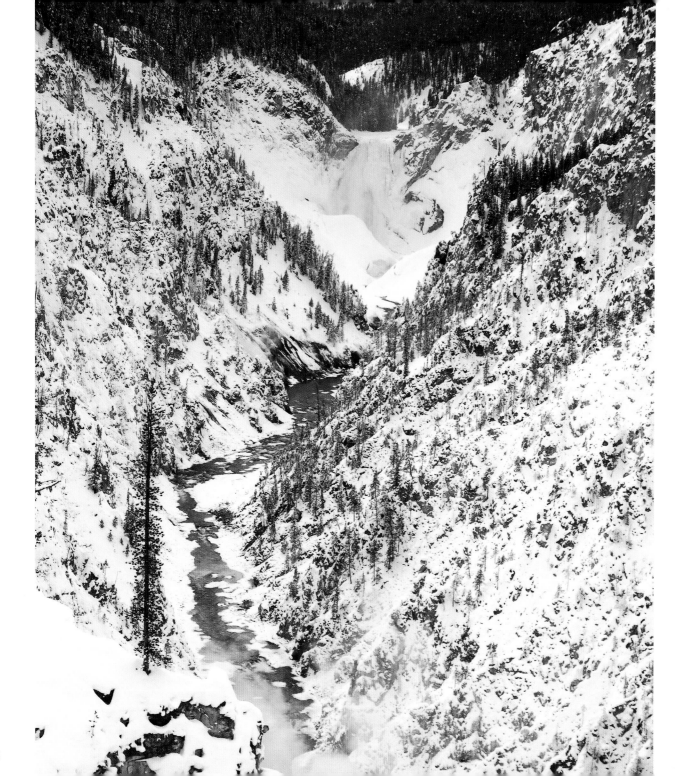

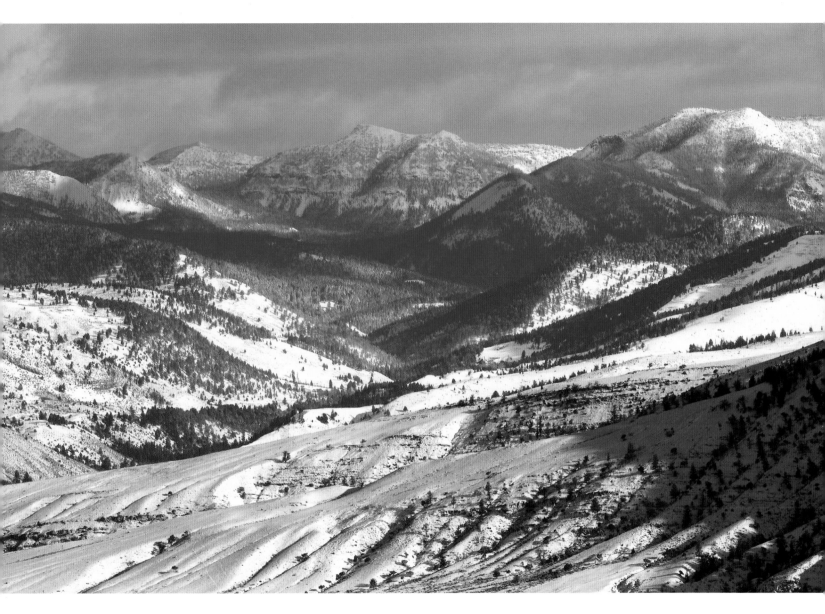

**Above:** The Absaroka Range stretches from south-central Montana into Wyoming's northwestern corner. The northern portion can be seen from the Mammoth Hot Springs area.

**Facing page:** The Grand Canyon of the Yellowstone from Artist Point is one of the iconic images in North America. While its grandeur is appreciated at any time, it appears even more pristine in winter.

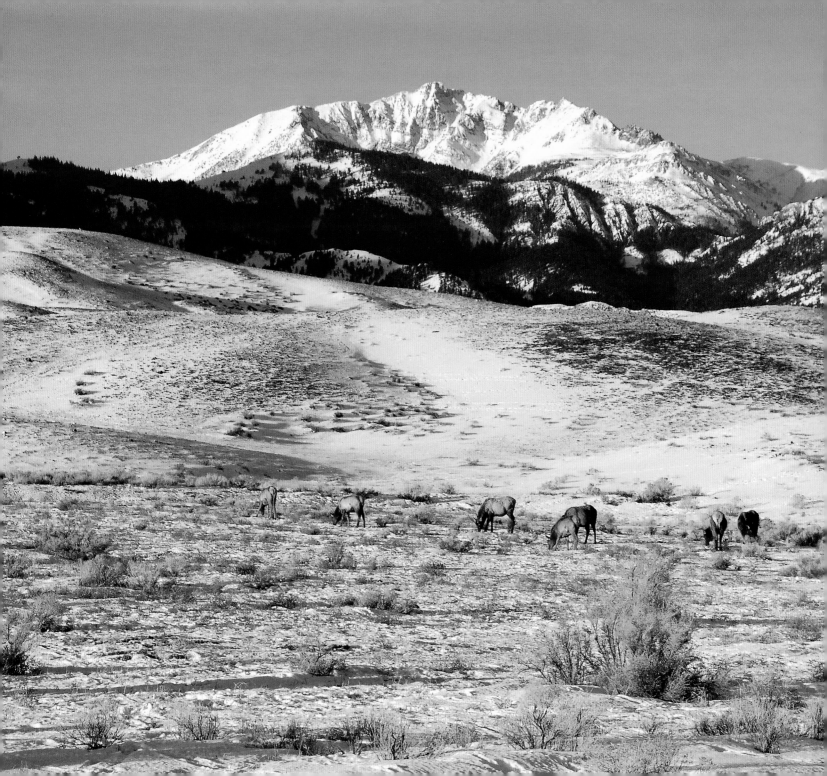

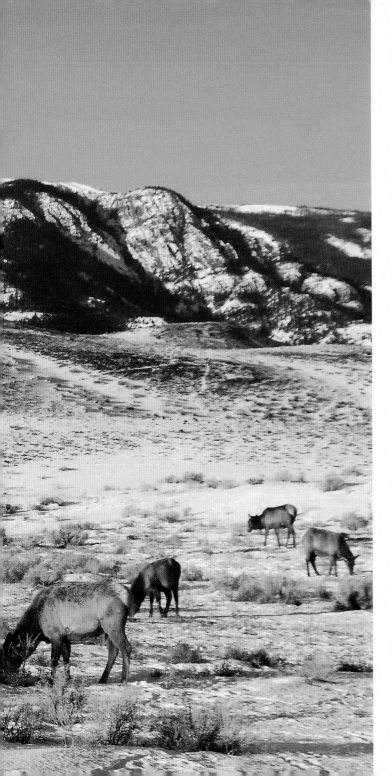

**Left:** The North Entrance area of the park receives lower precipitation due to lower elevation and the rain shadow effect from Electric Peak. Elk migrate here for better survival in winter.

**Below:** The Chocolate Pots along the Gibbon River.

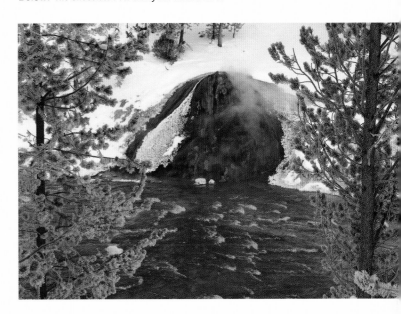

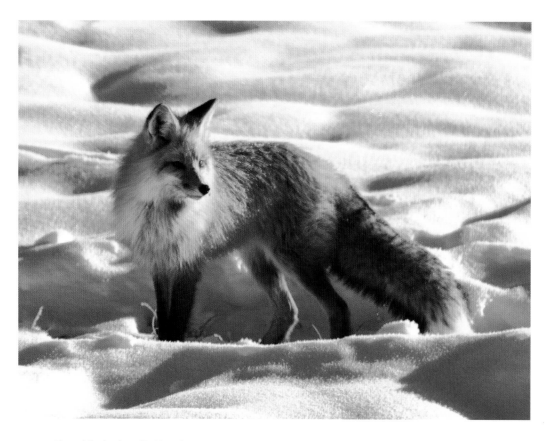

**Above:** The red fox has benefited from the reintroduction of wolves in Yellowstone. Coyotes prey on red foxes, and the presence of wolves in the park has suppressed the coyote population.

**Right:** Cross-country skiers begin their day of adventure by watching the eruption of Old Faithful Geyser.

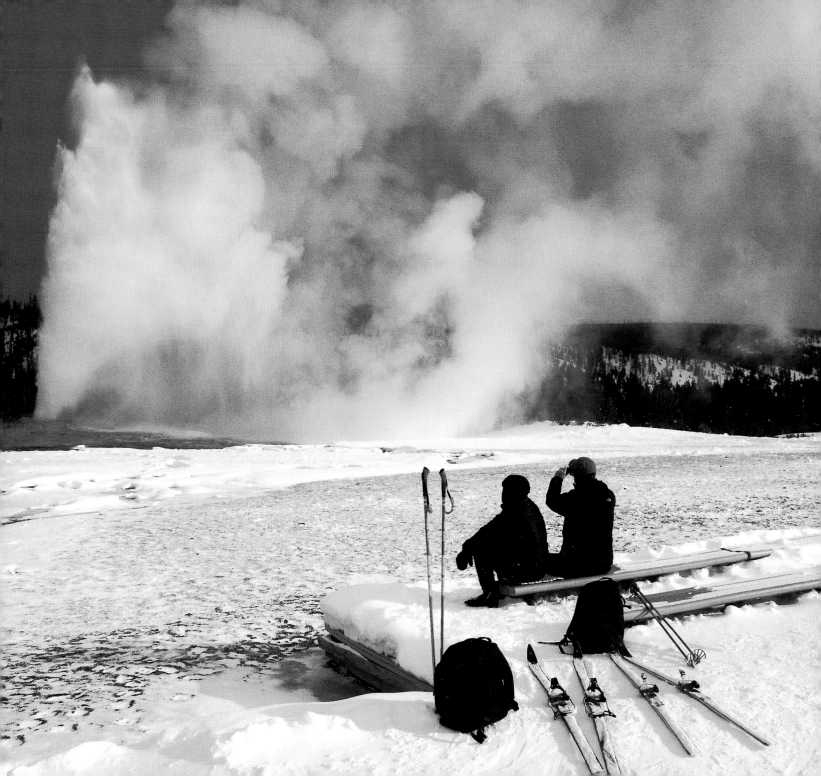

*Right:* A stroll on Geyser Hill in the Old Faithful area has an otherworldly feel in winter.

*Below:* Pronghorns migrate out of the park in winter, but some, like this one with bushy eyebrows, might be spotted on Old Yellowstone Trail near Roosevelt Arch.

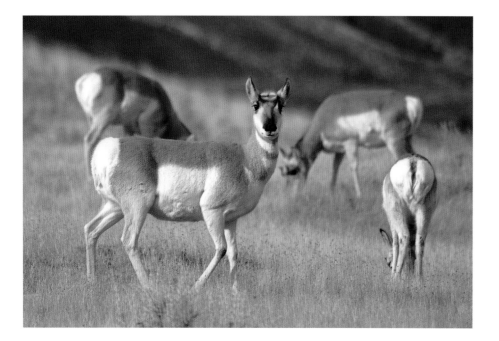

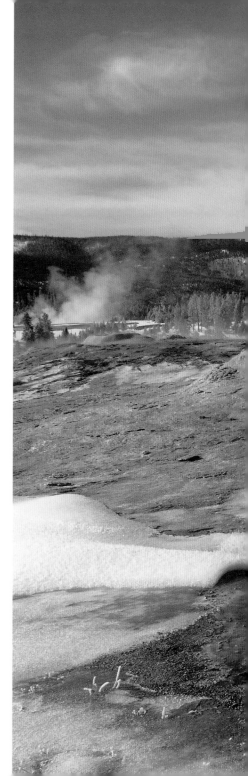

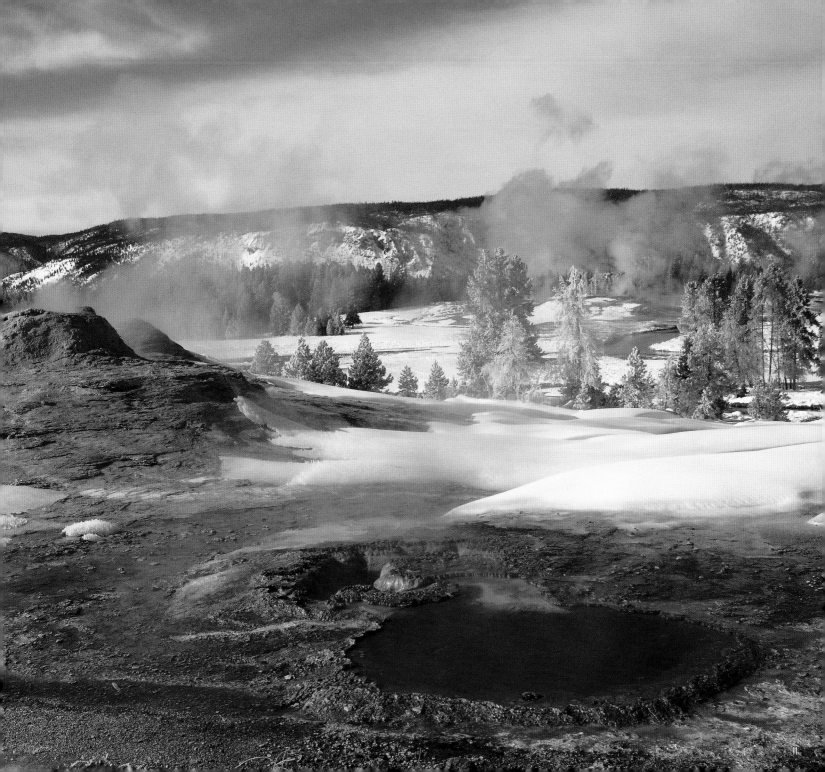

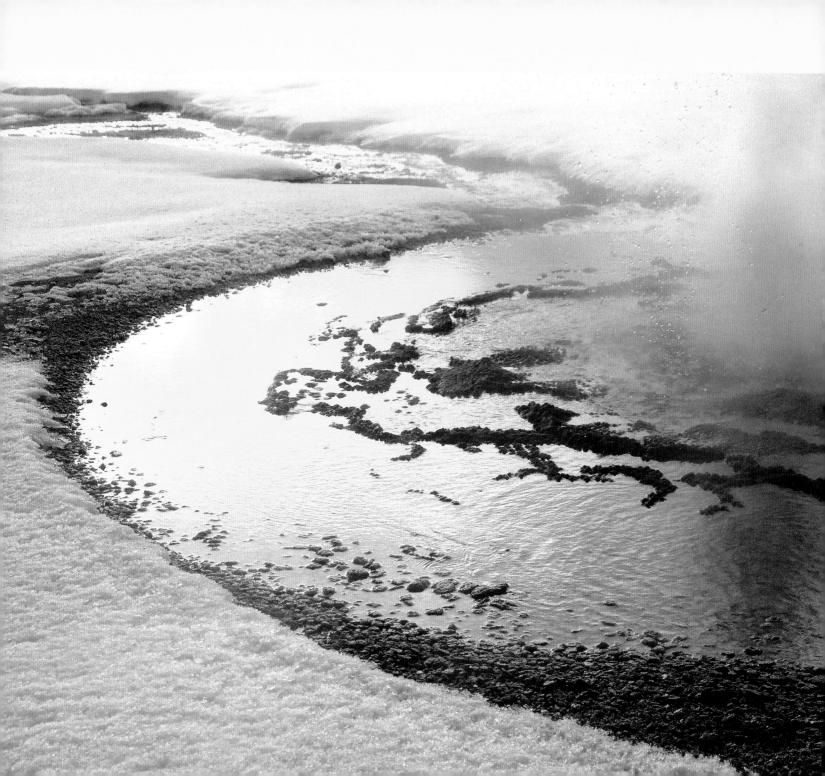

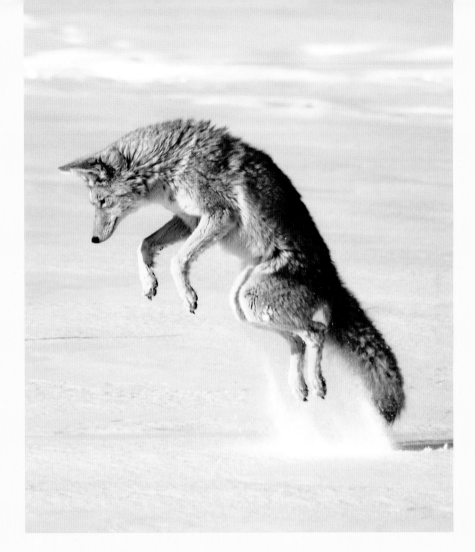

**Above:** This coyote leaps in midair to pounce on its prey under the snow, seen at a serendipitous moment from a snowcoach.

**Left:** The runoff from the erupting Tardy Geyser contrasts the golden light of sunset against the white snow.

**Right:** Black Growler is a steam vent that attracts attention upon entering Porcelain Basin, part of the larger Norris Geyser Basin. Mount Holmes can be seen in the distance when the weather cooperates.

**Below:** Yellowstone tells the story of life and death by letting nature take its course.

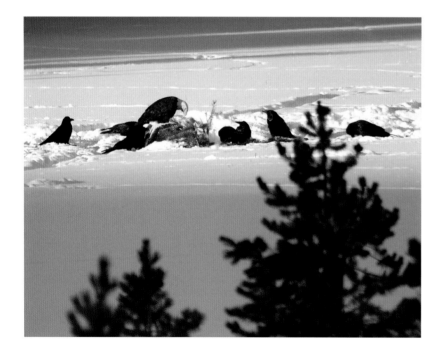

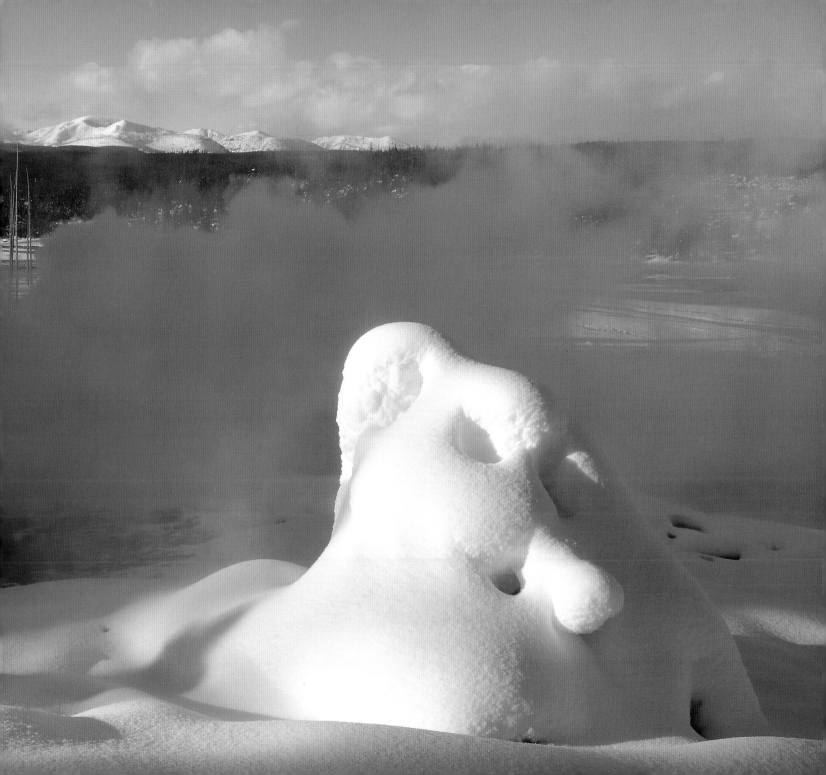

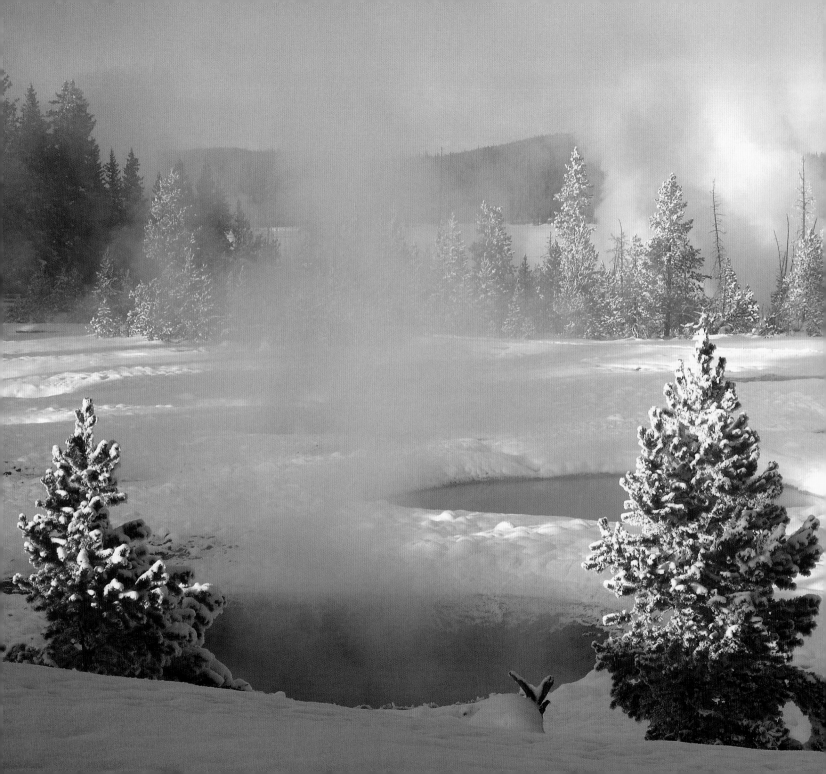

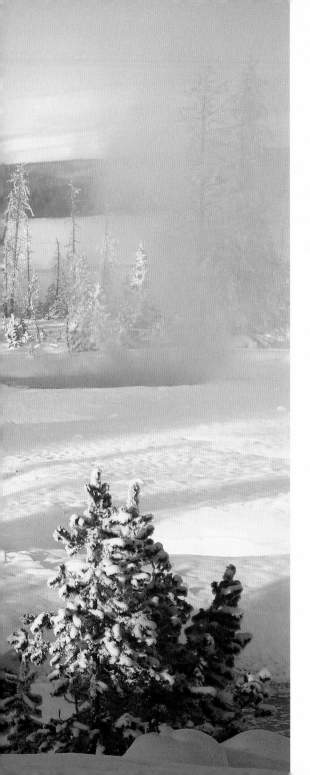

*Left:* Snow and steam transform West Thumb Geyser Basin into a Yellowstone-style winter wonderland.

*Below:* Bison in winter are often covered with snow because of their habit of sweeping their head in the snow to uncover grass.

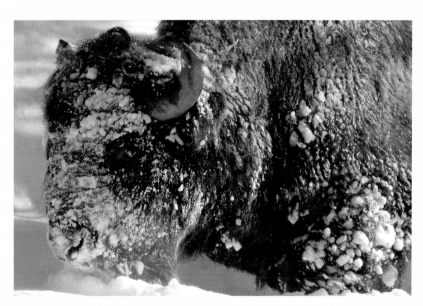

**Right:** The Gallatin Range pops up as a snowcoach enters Swan Lake Flat from Golden Gate Canyon, just south of Mammoth Hot Springs.

**Far right:** With summer crowds long gone, Old Faithful Inn sits in quiet winter splendor.

**Below:** A fogbow, or white rainbow, arcs over a group of snowmobiles at West Thumb.

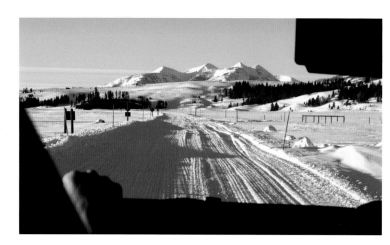

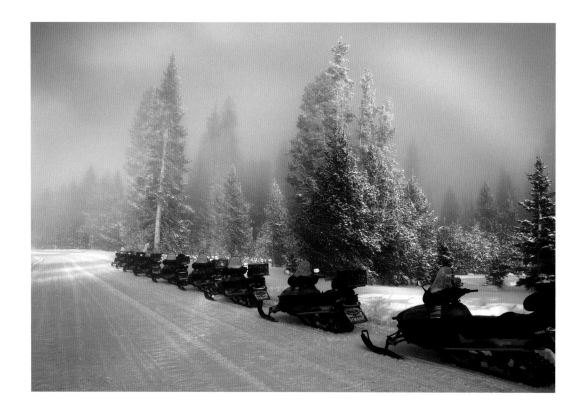

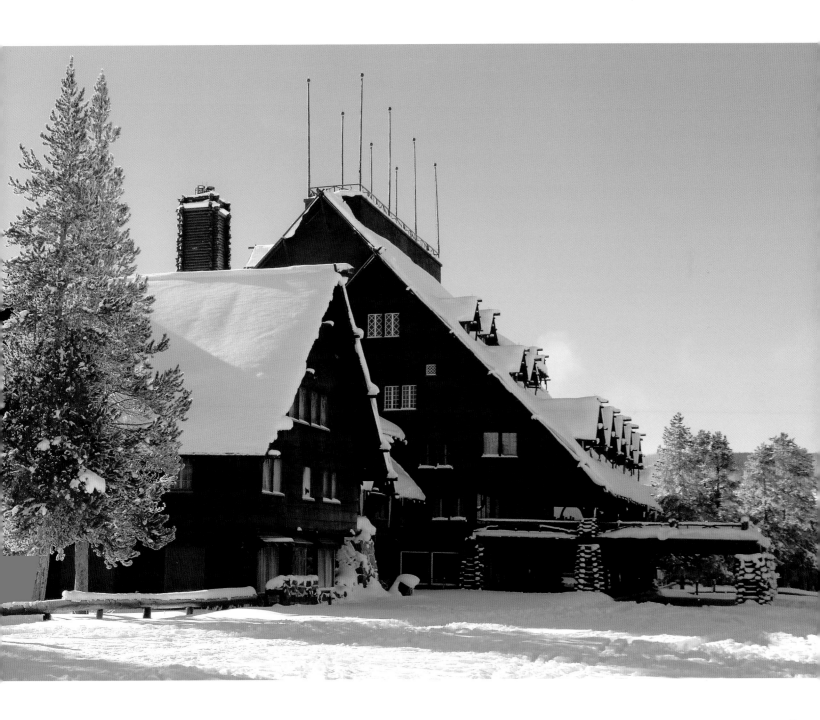

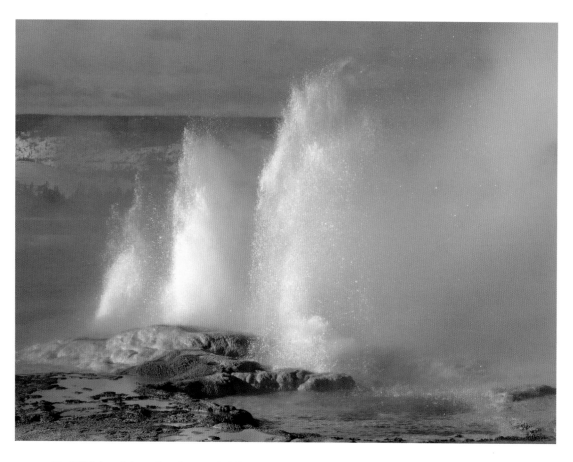

*Above:* The 1959 Hebgen Lake earthquake converted Clepsydra Geyser in Lower Geyser Basin into a constant performer. Its continuous action makes it a favorite geyser of visitors.

*Right:* The vast open space without shelter in Lamar Valley does not bother this herd of bison. They seem to live a cozy life even in winter.

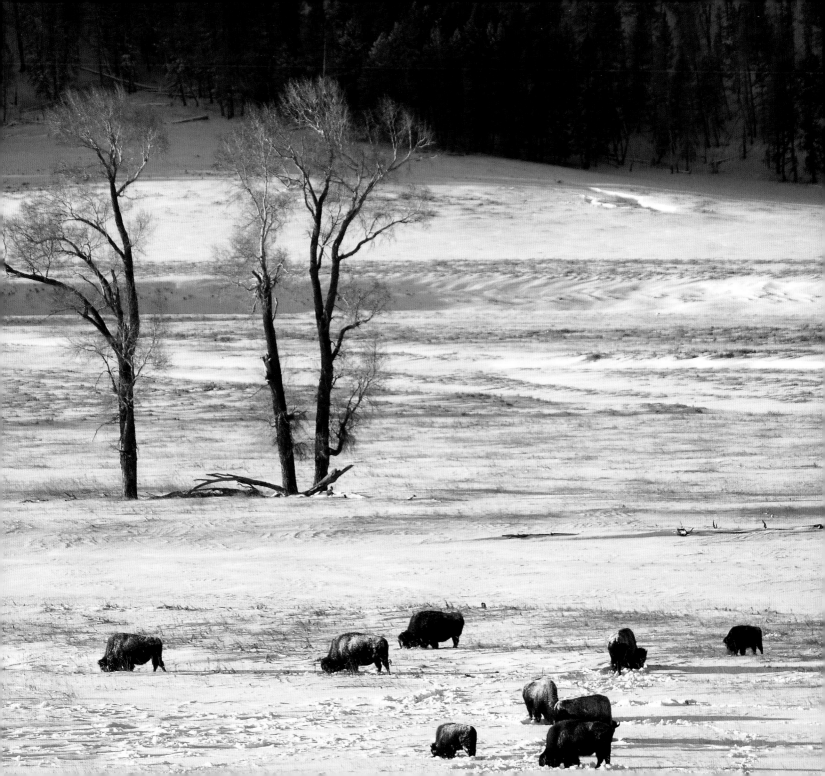

*Right:* The constant supply of steam in Upper Geyser Basin creates an exceptionally frosty winter scene.

*Below:* I took this shot of the Lamar Canyon pack in Lamar Valley on the last day of March in 2011. At that time the celebrated "06 Female" still led the pack.

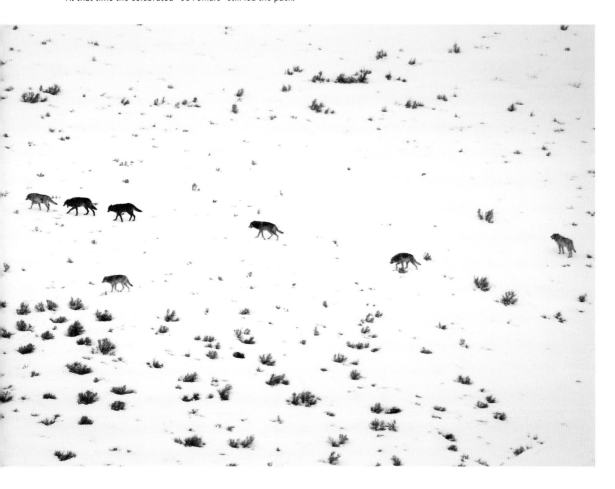

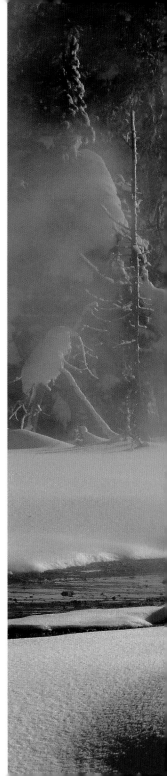

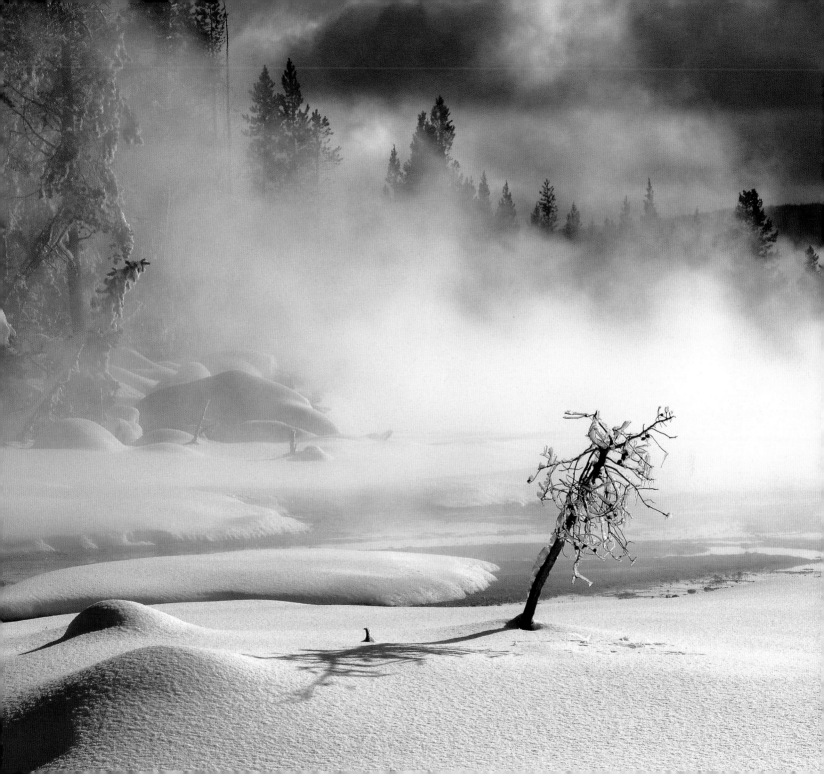

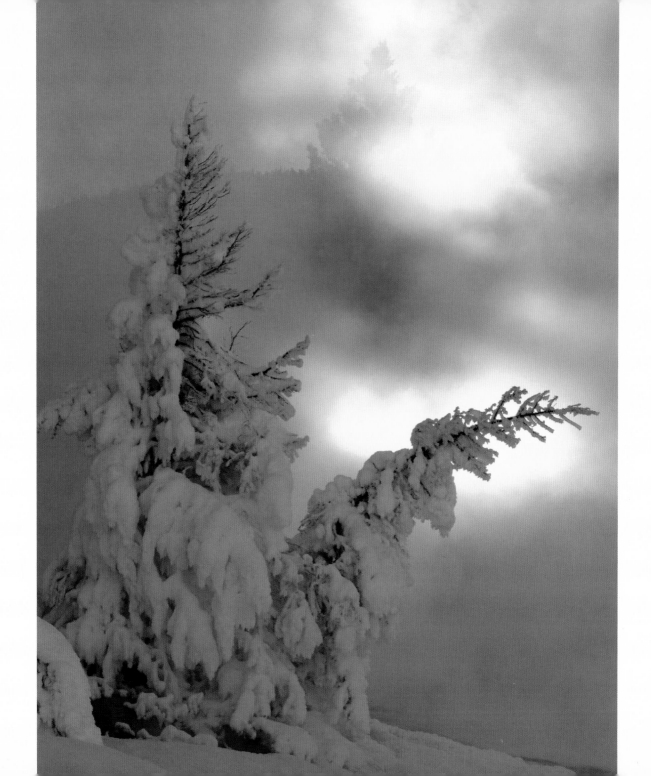

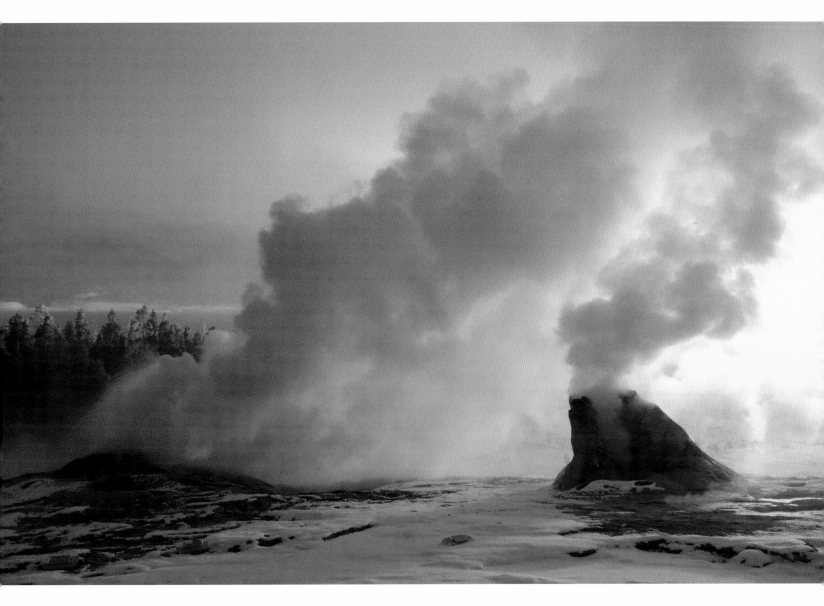

***Above:*** Giant Geyser has been in a somewhat dormant mode for decades. It is speculated that its energy shifted to nearby thermal features in the mid-1950s, but it is slowly becoming active again.

***Facing page:*** Drifting steam creates drama in the forest at Mammoth Hot Springs.

*Right:* Black Pool in West Thumb Geyser Basin is no longer black, but a brilliant blue-green color. Rising water temperatures in the early 1990s killed the darker cyanobacteria that thrived in the once cooler water and gave the pool its name.

*Below:* Fountain Paint Pot in Lower Geyser Basin is perhaps the most visited mudpot among many in the park. Its name comes from the variety of colors of mud in this area.

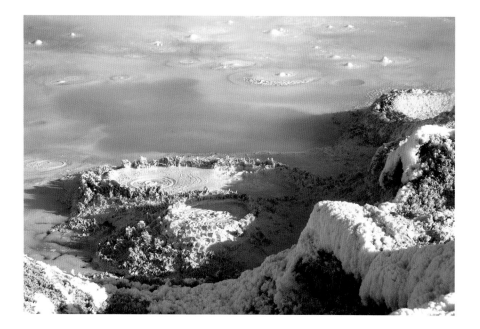

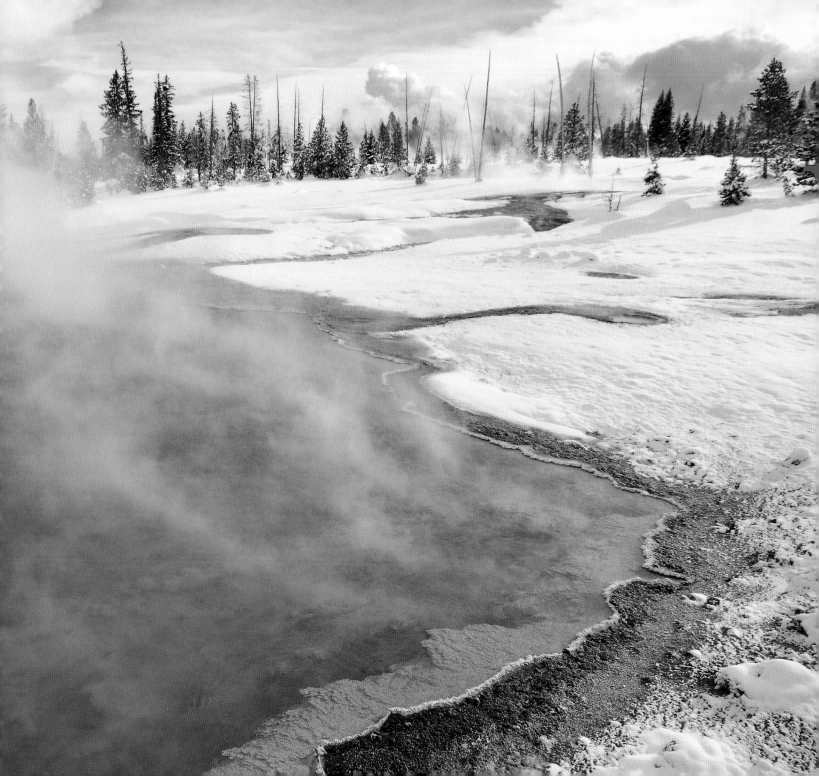

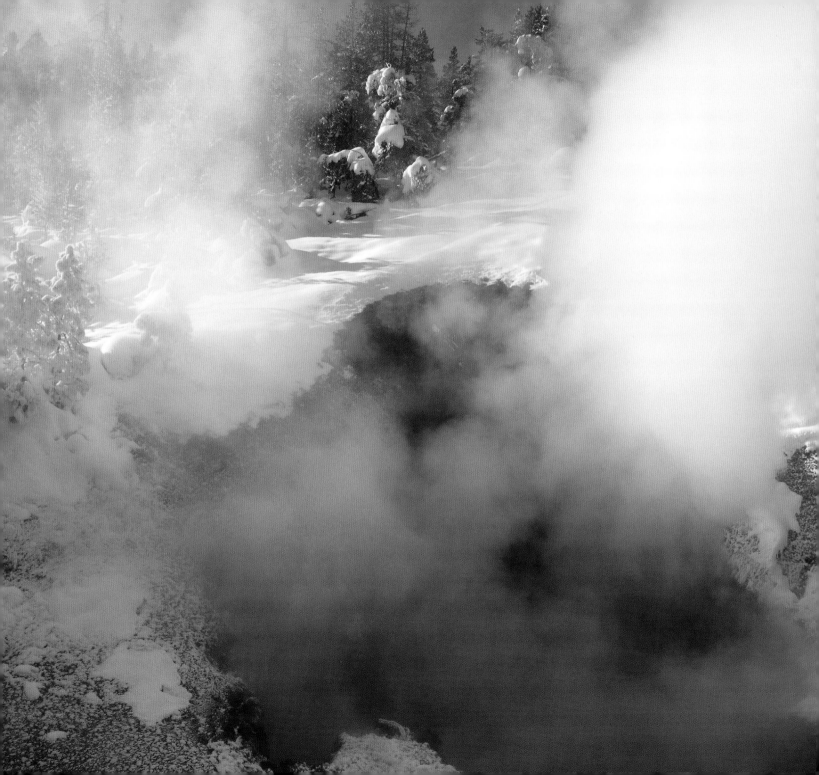

**Left:** The volcanic events and geothermal activities in the park suggested bizzare creatures to early visitors, such as Dragon's Mouth Spring in the Mud Volcano area, just north of Yellowstone Lake.

**Below:** Bighorn sheep are frequently seen in Gardner Canyon, especially in winter. Both rams and ewes grow horns, but only rams have the massive C-shaped horns.

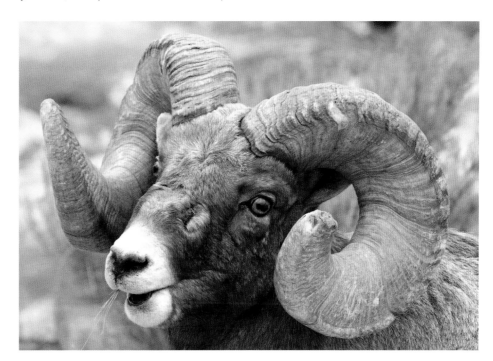

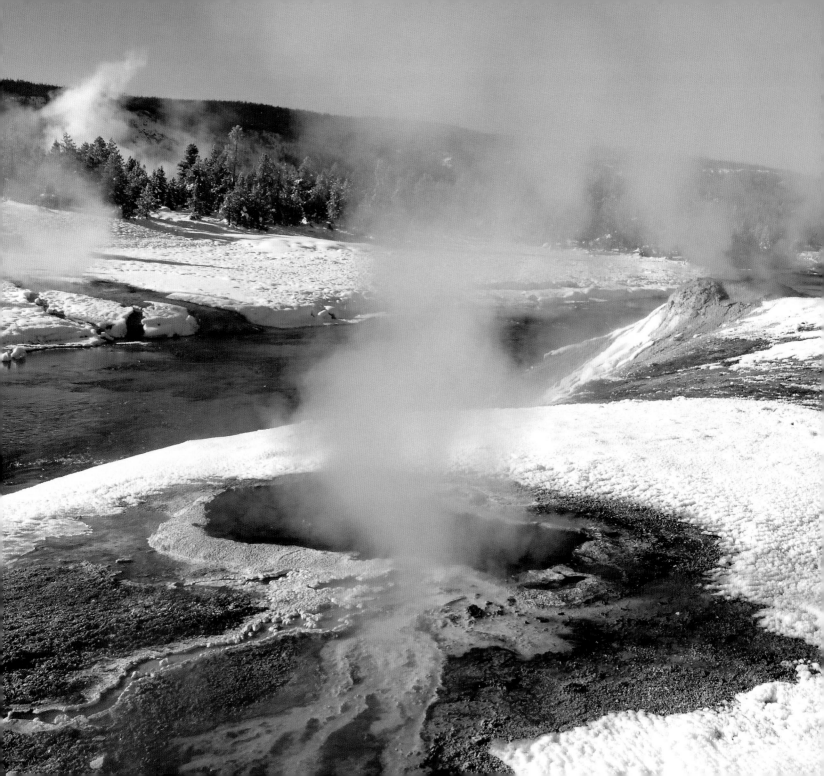

*Left:* South Scalloped Spring is one of many hot springs dotting the banks of the Firehole River.

*Below:* Thermal water trickles down travertine terraces from Canary Spring at Mammoth Hot Springs.

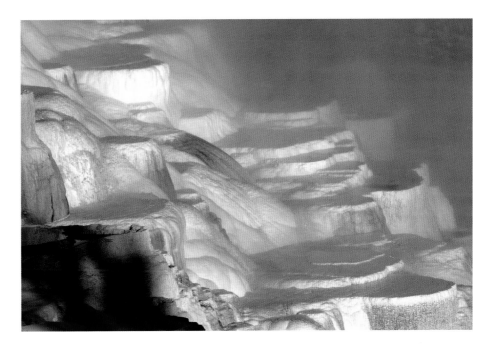

**Right:** The gray jay is a year-round resident in Yellowstone. This one was spotted at Geyser Hill in the Old Faithful area.

**Far right:** Heat-loving microbes, or thermophiles, thrive in and around thermal water and produce the vibrant color seen here in West Thumb Geyser Basin.

**Below:** Trumpeter swans, resting on the Yellowstone River, seek open water in winter to feed on aquatic vegetation.

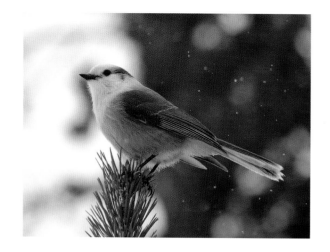

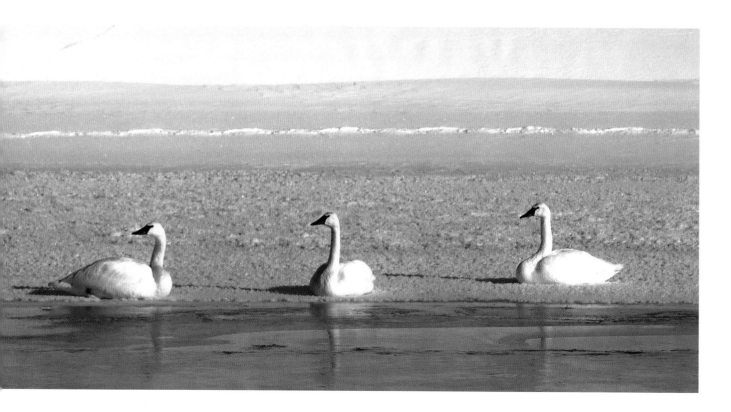

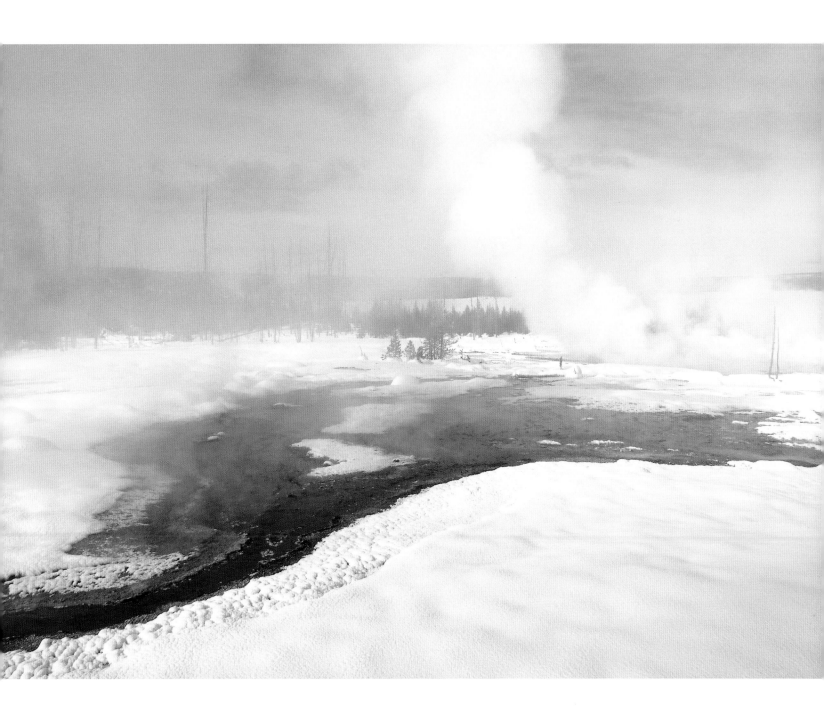

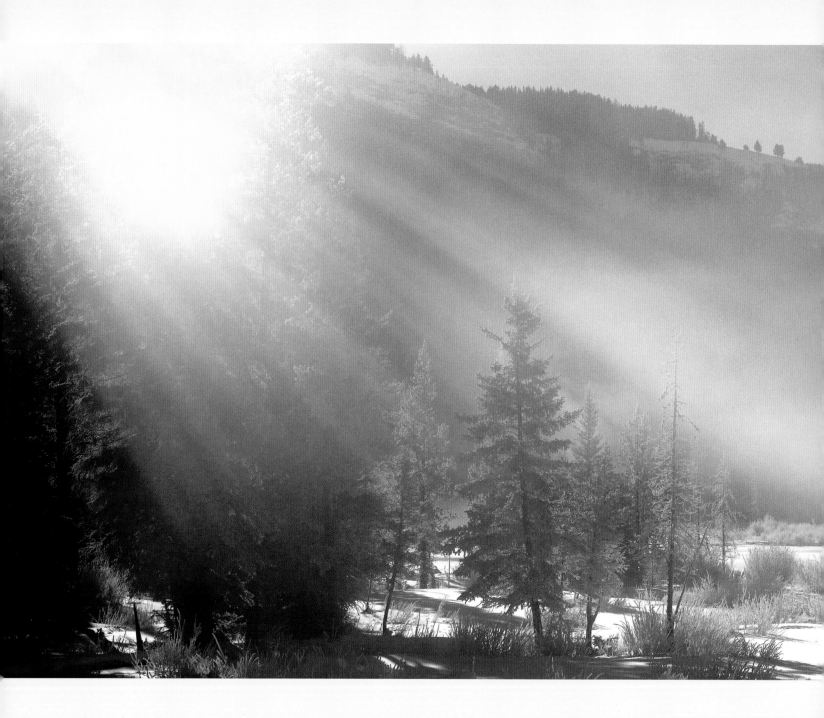

*Left:* Sunlight slices through morning fog to create rays of white light in the forest.

*Below:* Steam fog is formed when very cold air moves over open water.

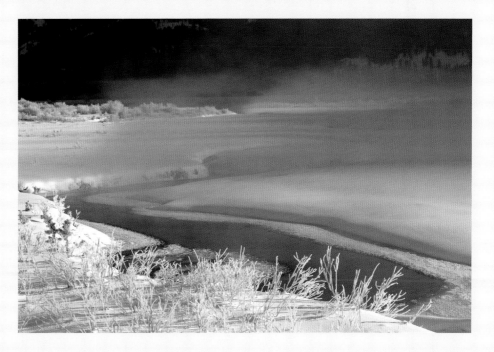

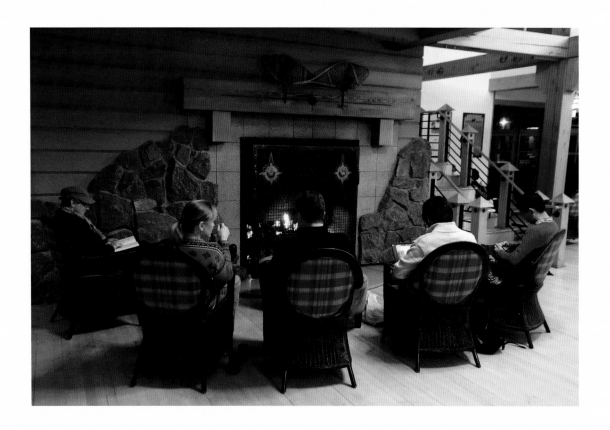

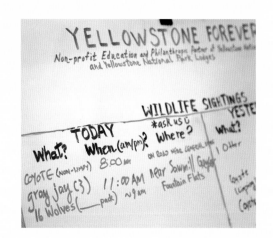

**These pages:** Old Faithful Snow Lodge provides full-service winter lodging in the Old Faithful area. In addition to enjoying the delightful fire, visitors can check the recent wildlife sightings and hopefully be lucky enough to also see sixteen wolves.

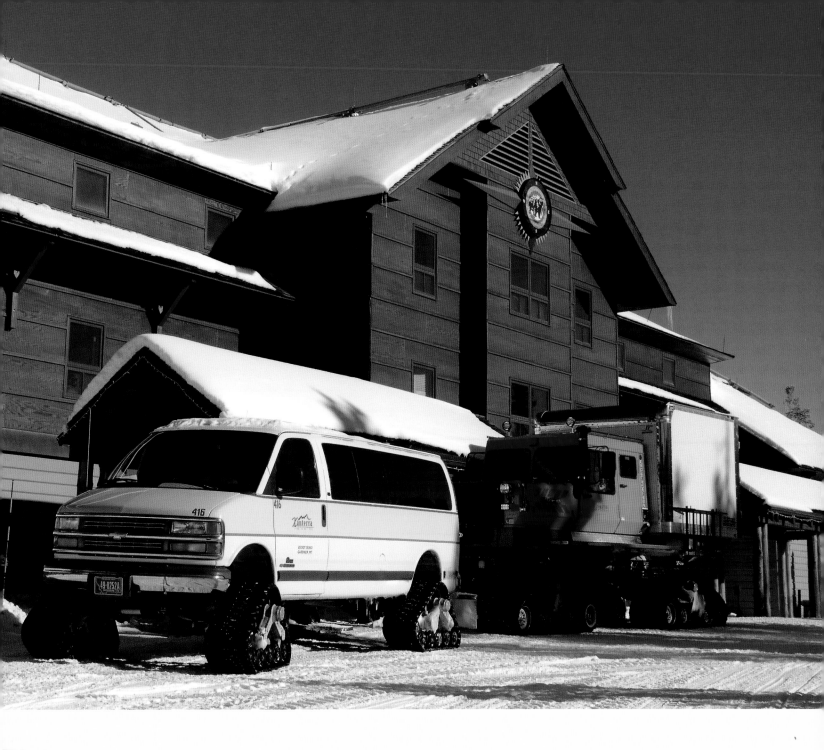

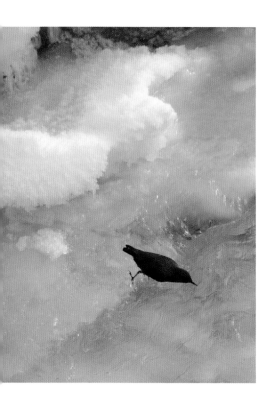 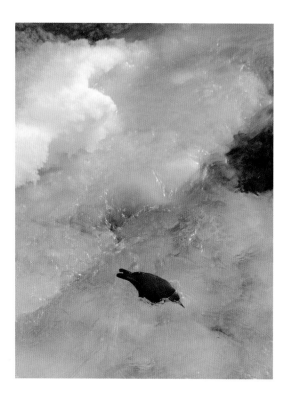 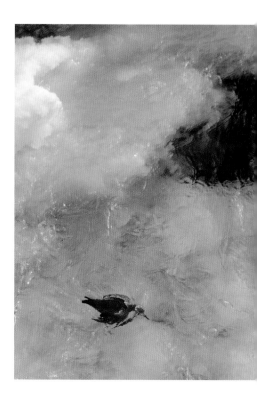

***Above three:*** American dippers are commonly seen along riverbanks. This dipper is hunting aquatic insects in the Yellowstone River below Chittenden Bridge near Canyon Village.

***Facing page:*** The milky blue pools in Porcelain Basin come from the saturation of siliceous sinter, also known as geyserite.

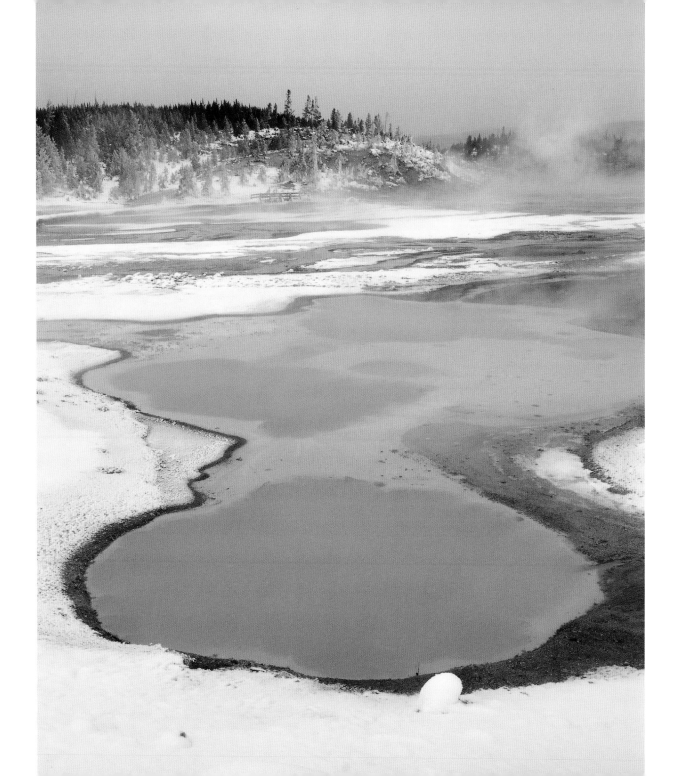

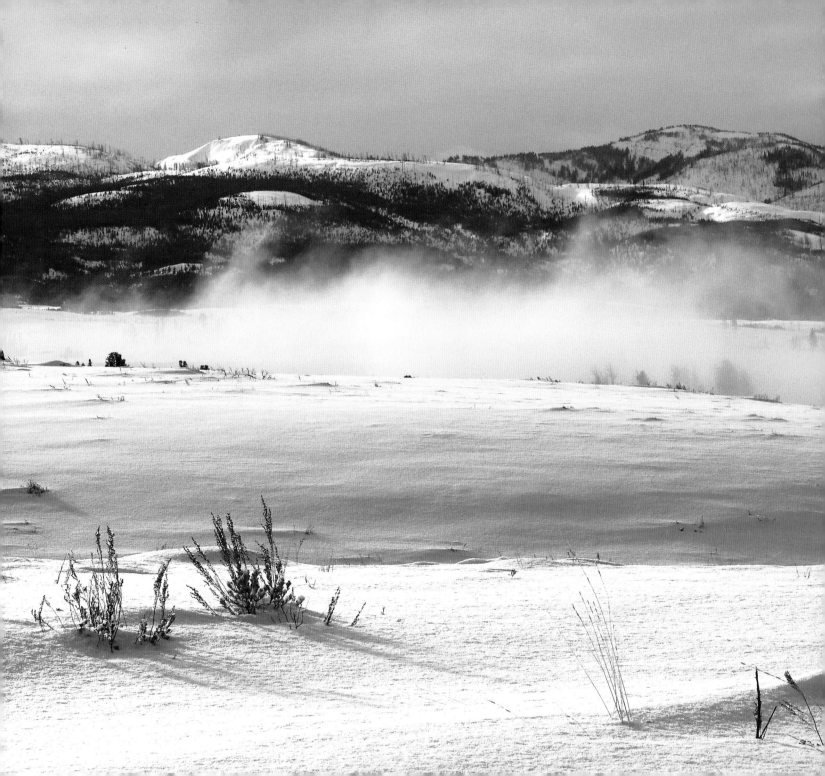

**Left:** A steely sky, lingering fog, and utter desolation in the Northern Range show the true force of winter.

**Below:** Before the creation of the National Park Service in 1916, Yellowstone was managed and protected by the U.S. Army. Lower precipitation at Mammoth Hot Springs made it an ideal spot to establish Fort Yellowstone as the headquarters. Today it stands as a reminder of this history.

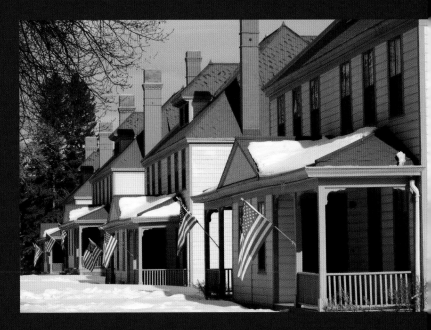

**Right:** The shape and color of Doublet Pool, near Old Faithful Geyser, make it one of the most appealing hot springs in the park.

**Below:** A bull elk grazes along the roadside near Tower Junction. He will shed his antlers in late February and then re-grow a new set.

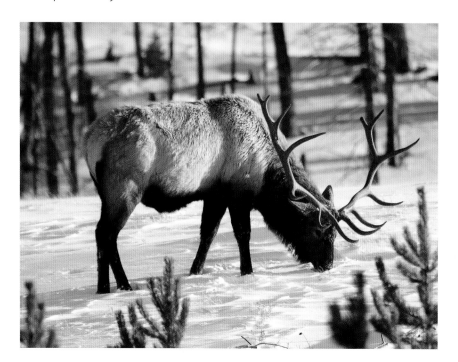

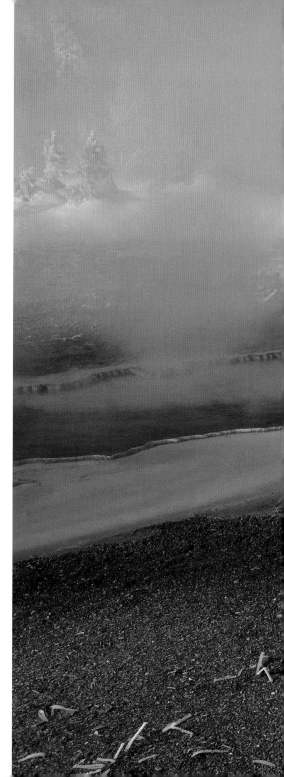

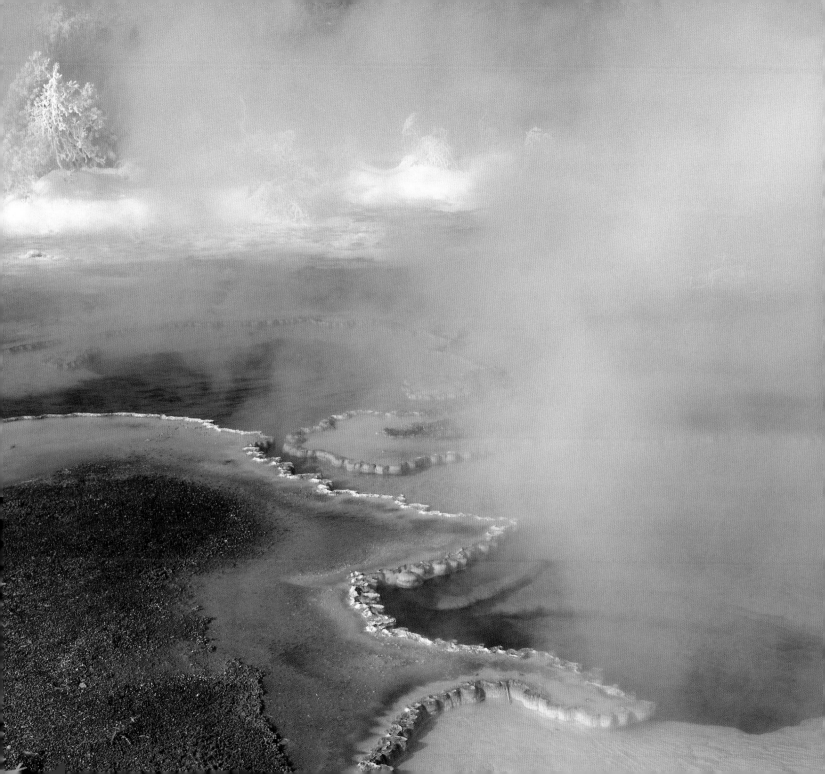

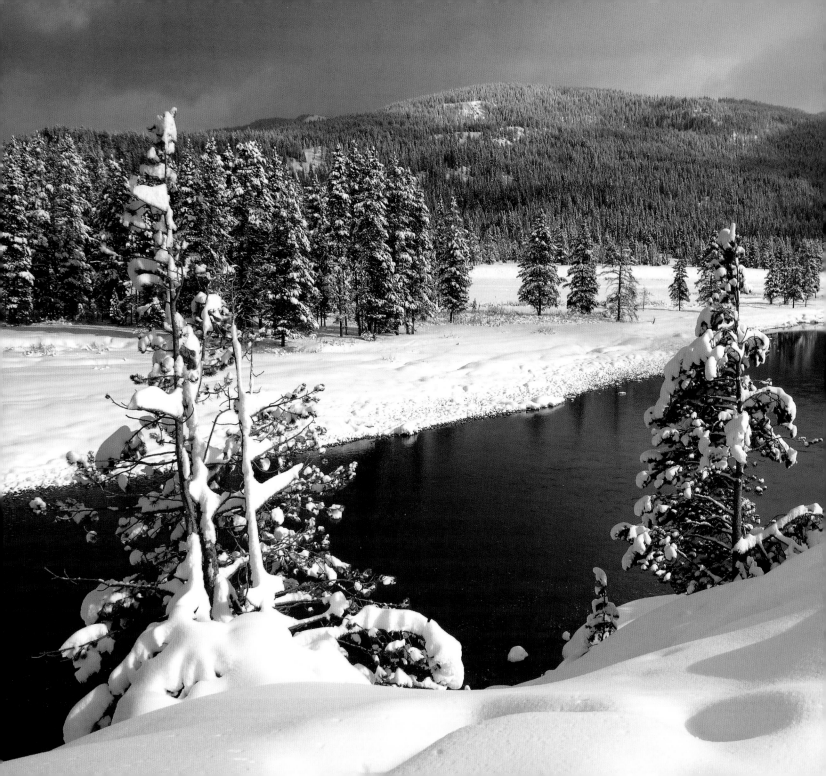

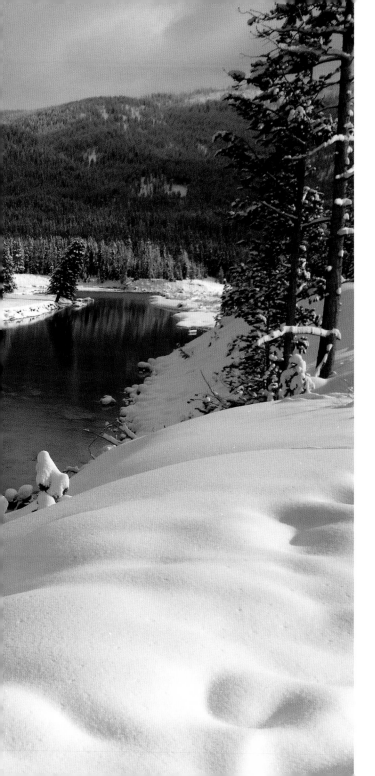

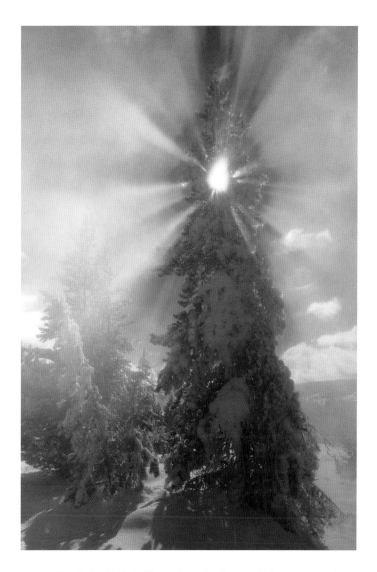

*Above:* The starburst effect of the sun's rays is often seen in thermal areas when steam drifts up from thermal pools.

*Left:* The Snake River originates in Yellowstone and eventually joins the Columbia River heading for the Pacific Ocean. The stillness seen here at the South Entrance is a moment frozen in time.

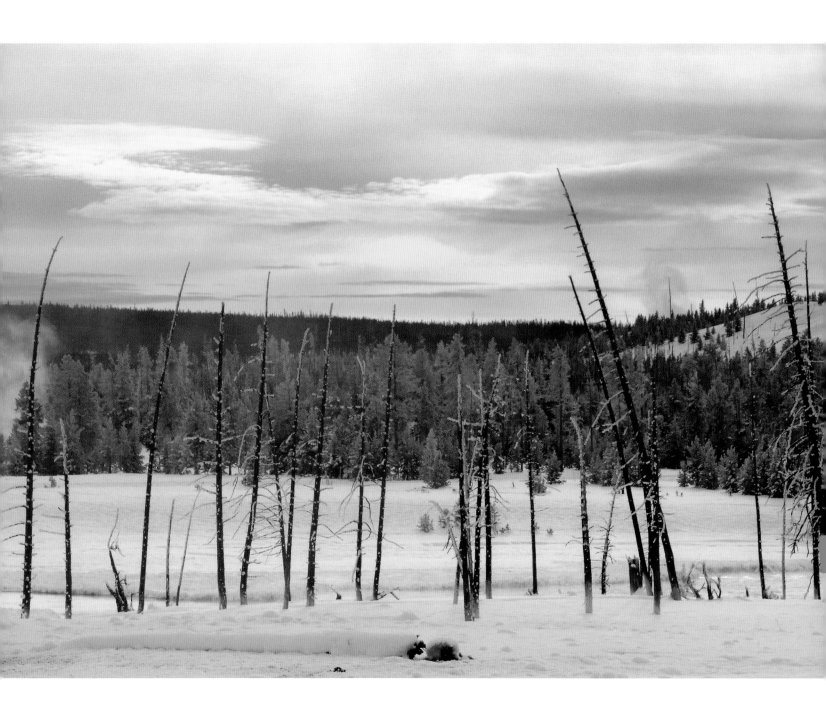

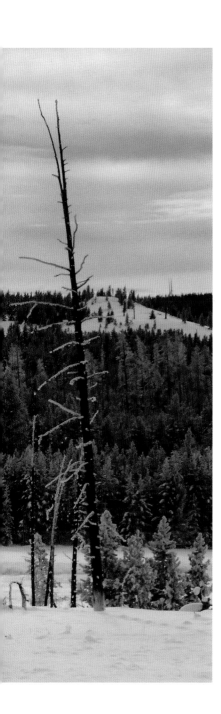

**Left:** In addition to dying in wildfires, lodgepole pines in thermal areas can drown in the superheated water of shifting thermal activities, leaving an eerie landscape.

**Below:** The way a forest regenerates after a wildfire can be observed in Lewis Canyon. The standing lodgepole pines died in the 1988 fire, and the small trees sprouted thereafter continue to grow vigorously.

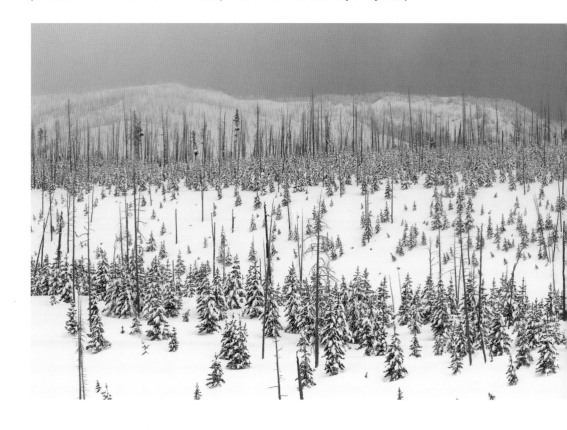

*Right*. Sawmill Geyser is a fountain-type geyser. It shoots water through the pool in various directions instead of straight up like Old Faithful Geyser.

*Below:* Although moose are not frequently seen in summer, some bull moose like to hang out at Pebble Creek in winter.

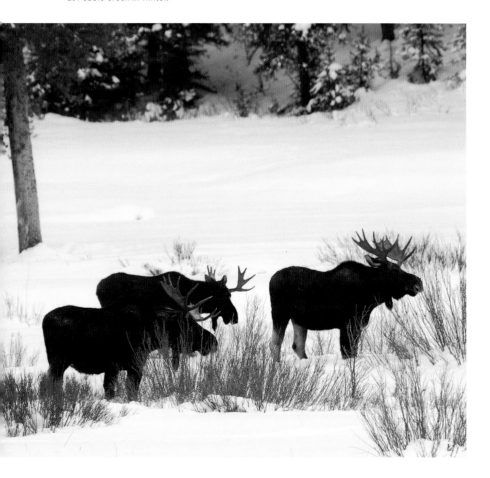

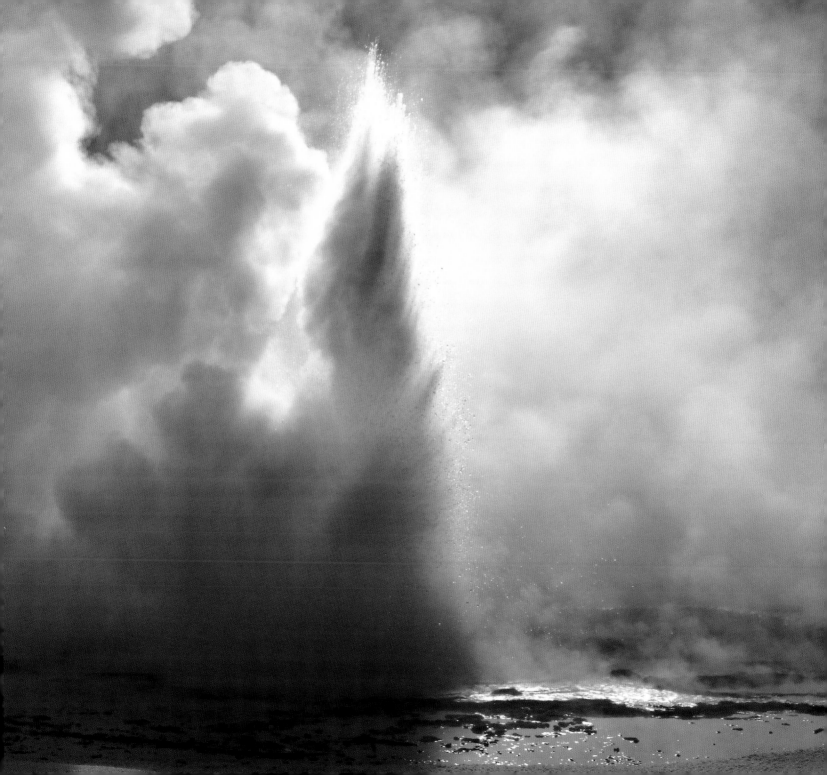

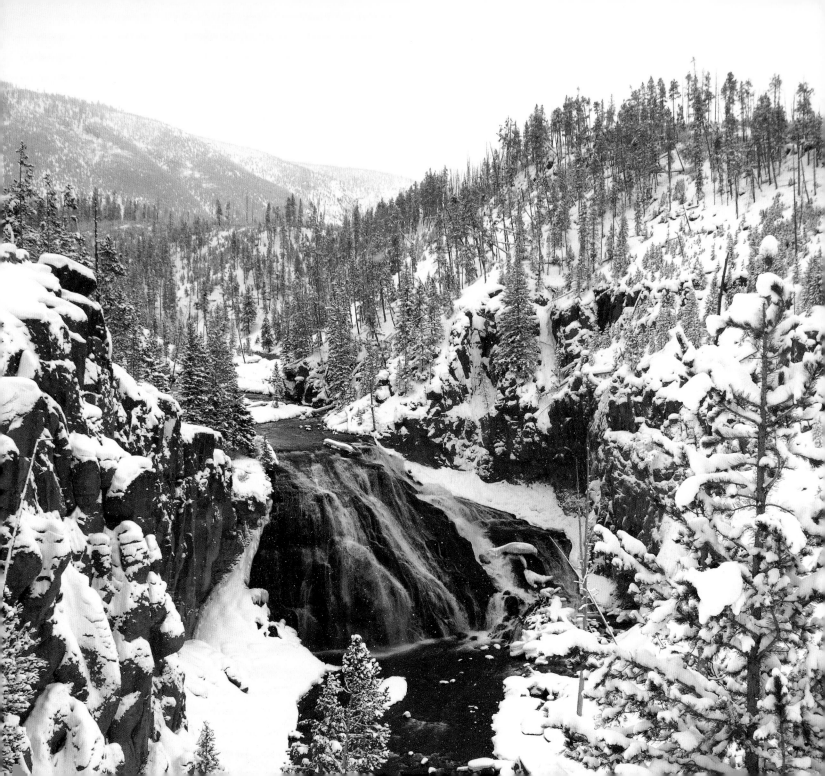

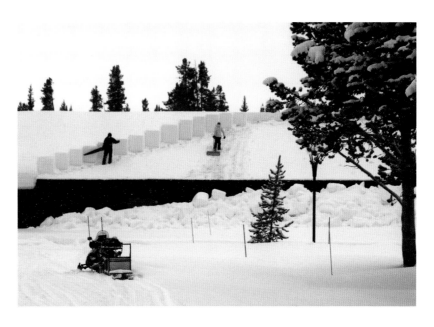

**Above:** Winter maintenance has long been a tradition in the park. Roof clearing is one of these tasks, as seen here on a late winter visit to Canyon Village.

**Left:** Gibbon Falls lies at the edge of the Yellowstone Caldera and conveys a sense of tranquility on an overcast day.

**Right:** Rising to almost 11,000 feet, Electric Peak is the tallest in the Gallatin Range. Swan Lake Flat is one of many places in the park to see it.

**Below:** A cross-country skier braves the trek to Fairy Falls on a snowy day.

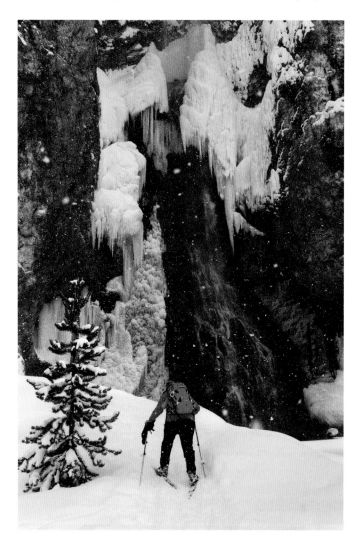

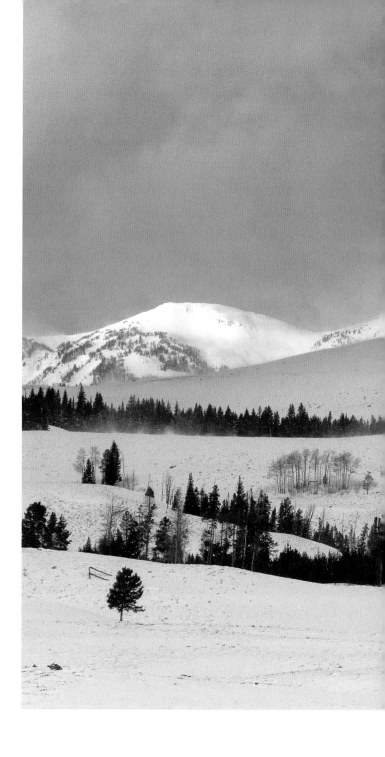

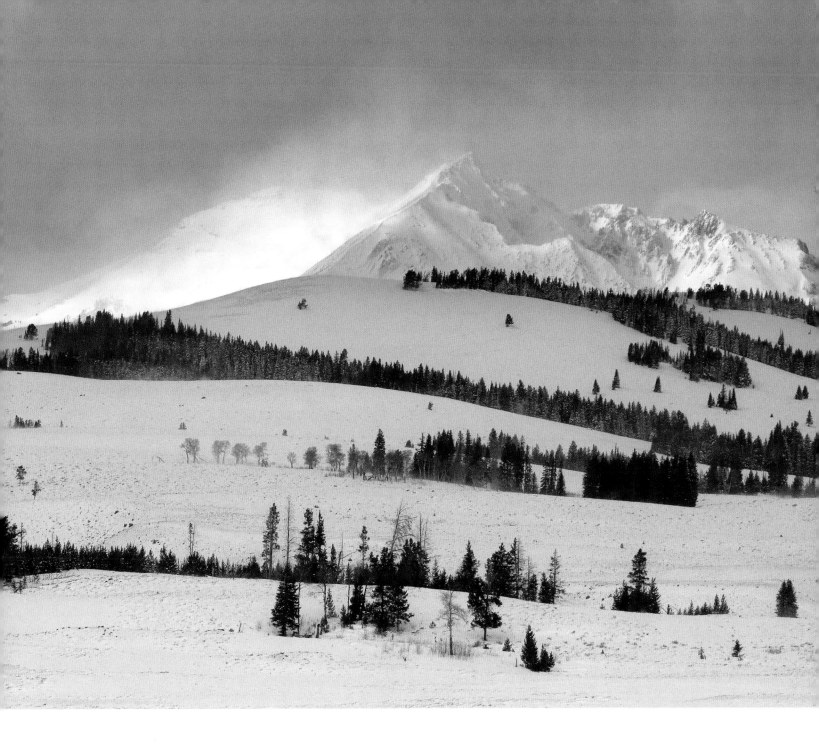

*Right:* In the midst of winter, the snow, willows, conifer forest, and blue sky combine to create a kaleidoscope of color near Pebble Creek in Yellowstone's northeast corner.

*Below:* A stormy sunset paints the Firehole River and hot spring runoff in Midway Geyser Basin.

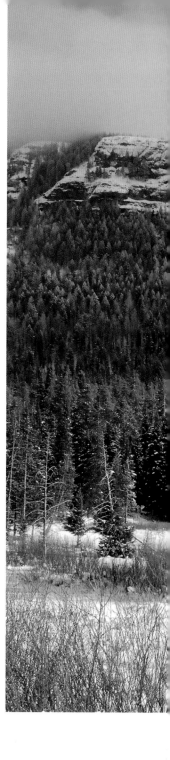

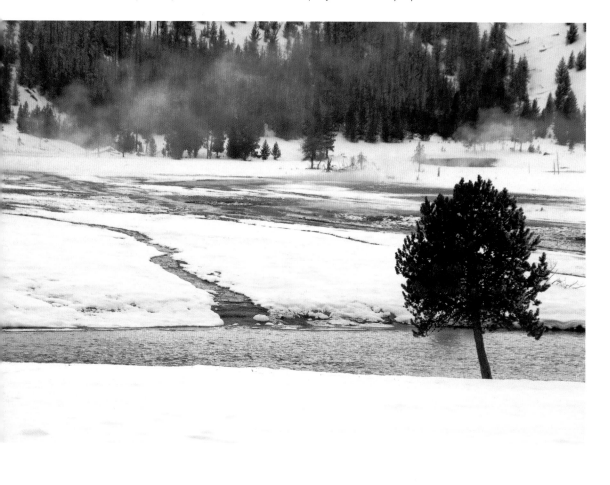

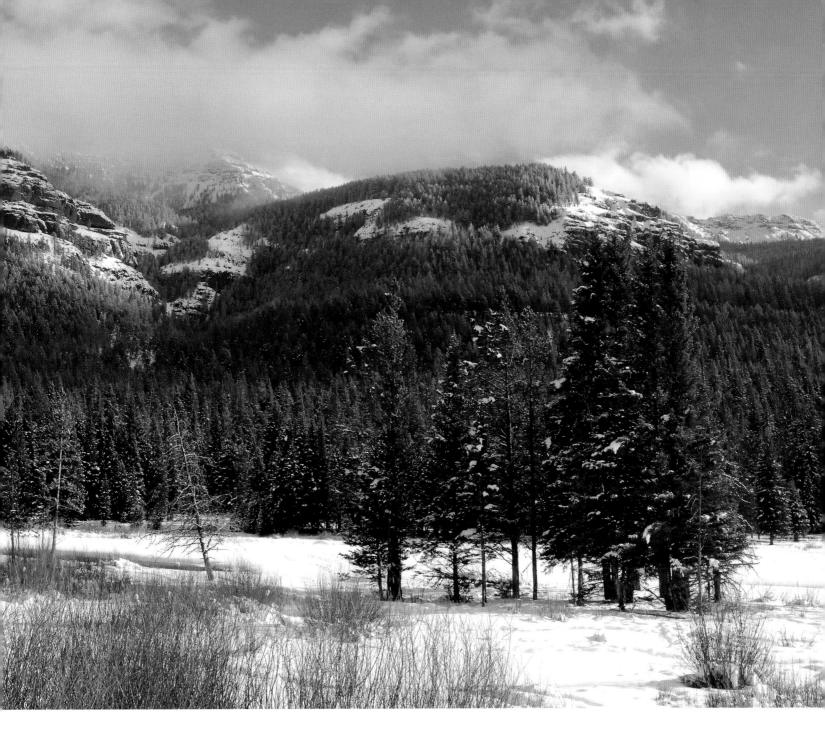

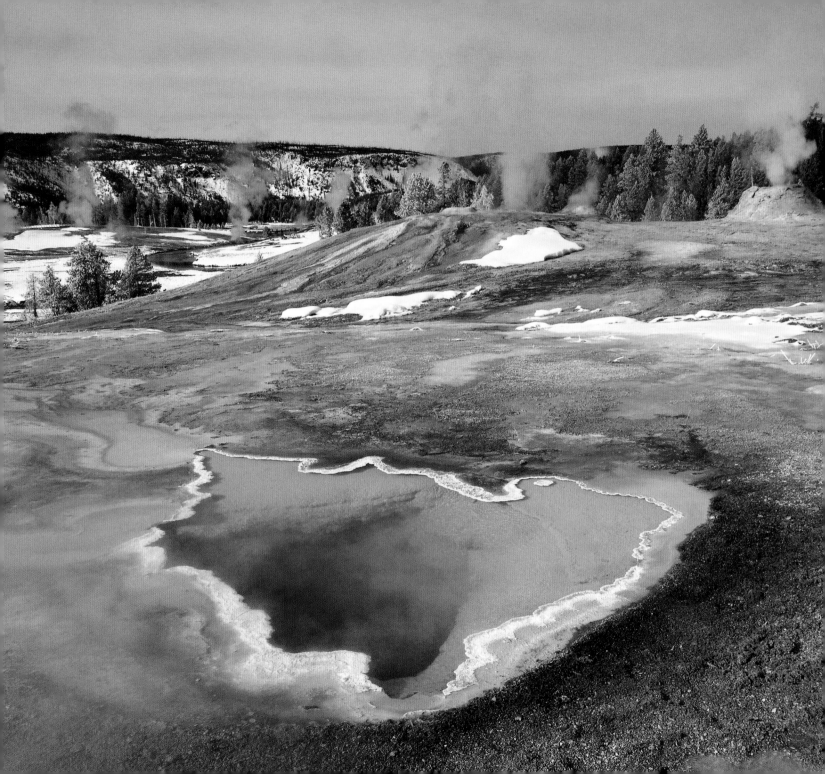

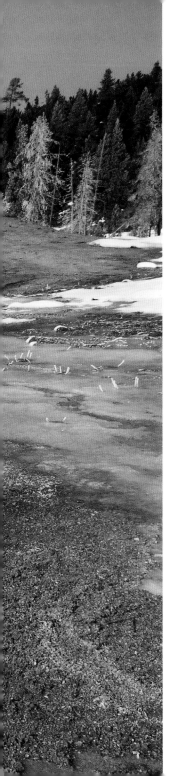

**Left:** With Heart Spring in the foreground, Upper Geyser Basin's Geyser Hill looks like a painting under the soft sunlight.

**Below:** Making your own trail in deep snow is slow and exhausting. A bison choosing to go alone, usually a bull, has to deal with this all winter long.

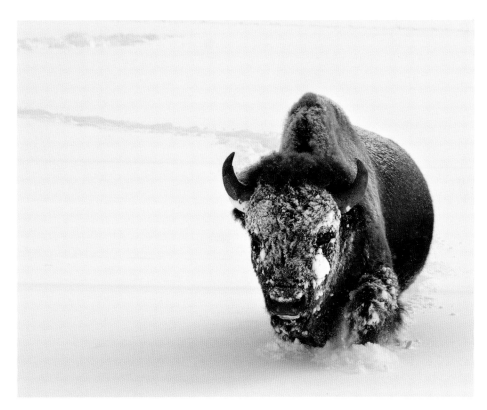

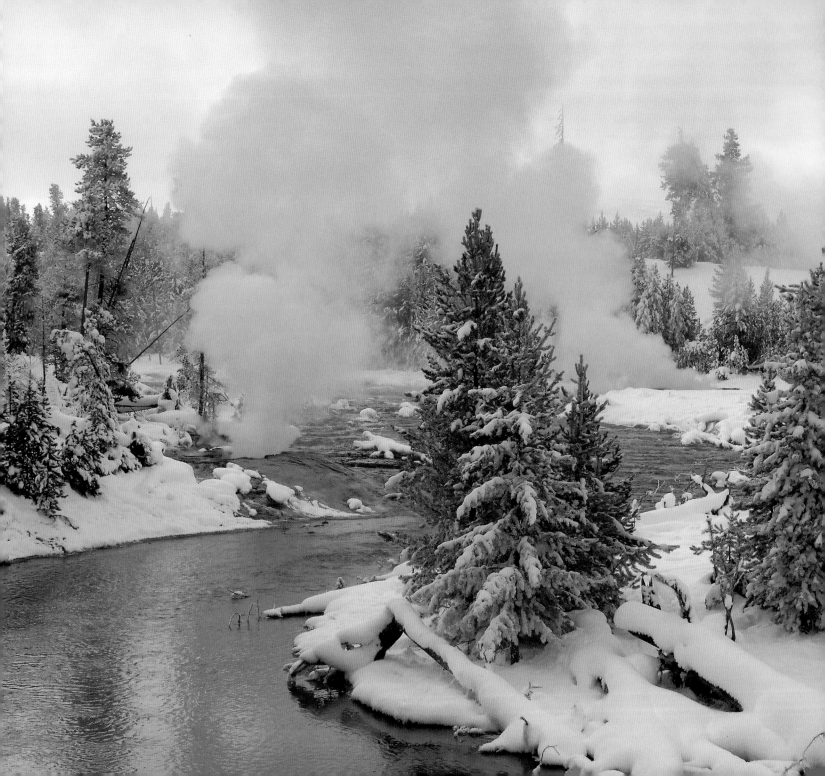

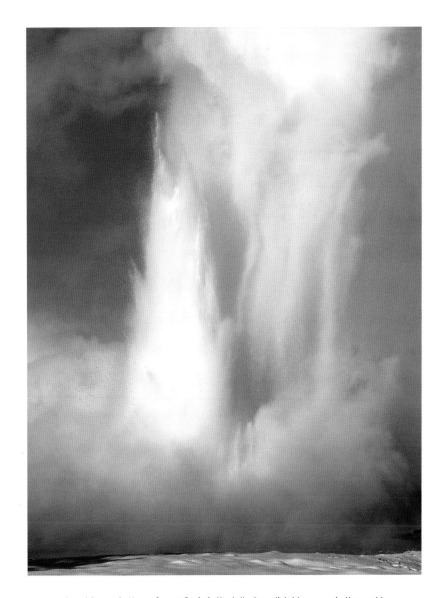

***Above:*** Grand Geyser in Upper Geyser Basin is the tallest predictable geyser in the world.

***Left:*** Firehole River is the main stream running through the geyser basins, adding a scenic backdrop to various thermal features, such as here near Morning Glory Pool.

**Right:** The sun peeks through the moving fog and wandering steam at Upper Geyser Basin.

**Below:** Elk rely on their long coat of guard hairs to keep them warm through the winter. If an elk loses too much of this coat due to disease or other causes, the loss of insulation can lead to its death from hypothermia.

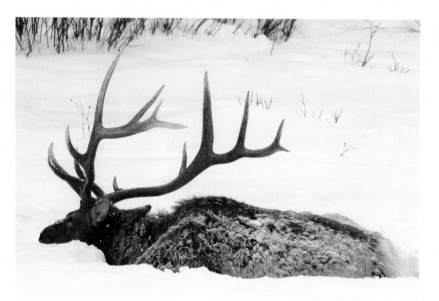

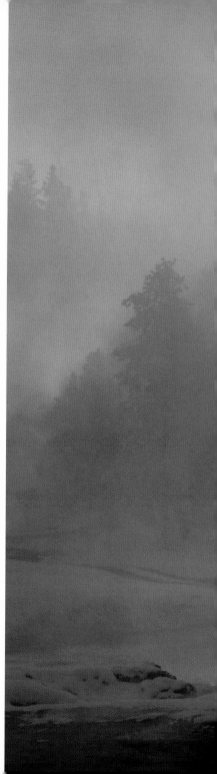

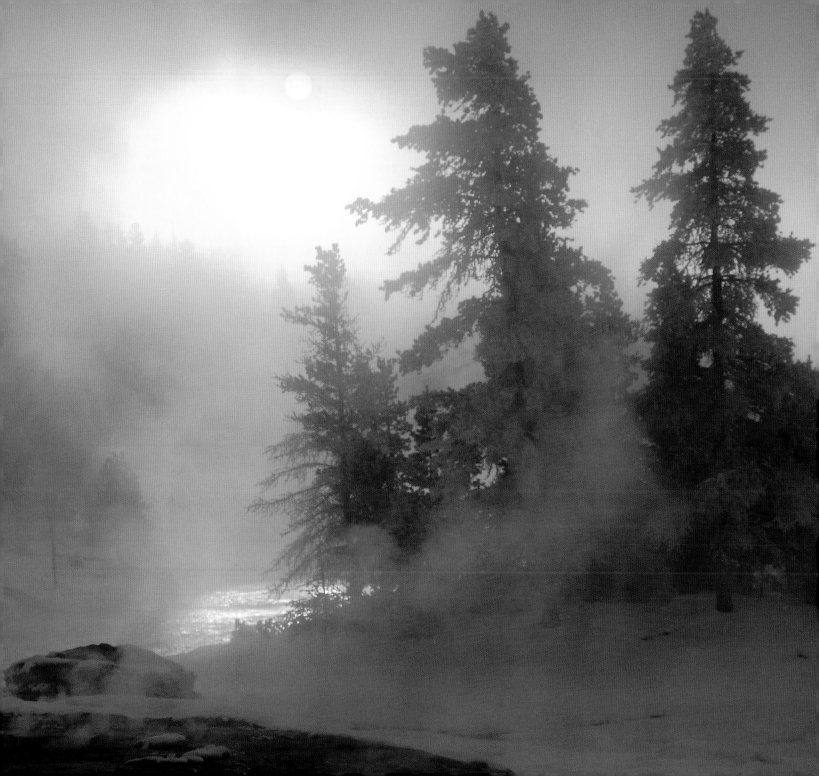

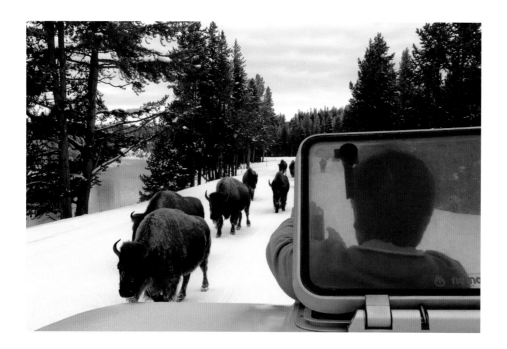

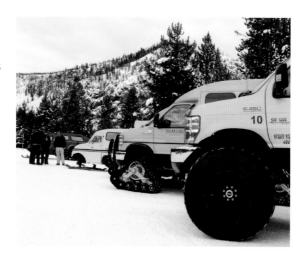

**Above:** To save energy, bison take advantage of groomed roads when they need to move. Two hatches on the Bombardier snowcoach allow visitors to stand up for an unobstructed view.

**Right:** While traditional tracked snowcoaches are still in operation, more eco-friendly low-pressure-tire snowcoaches have become the choice to transport visitors in winter.

**Far right:** A rainbow accompanies Castle Geyser at its post-eruption steam phase.

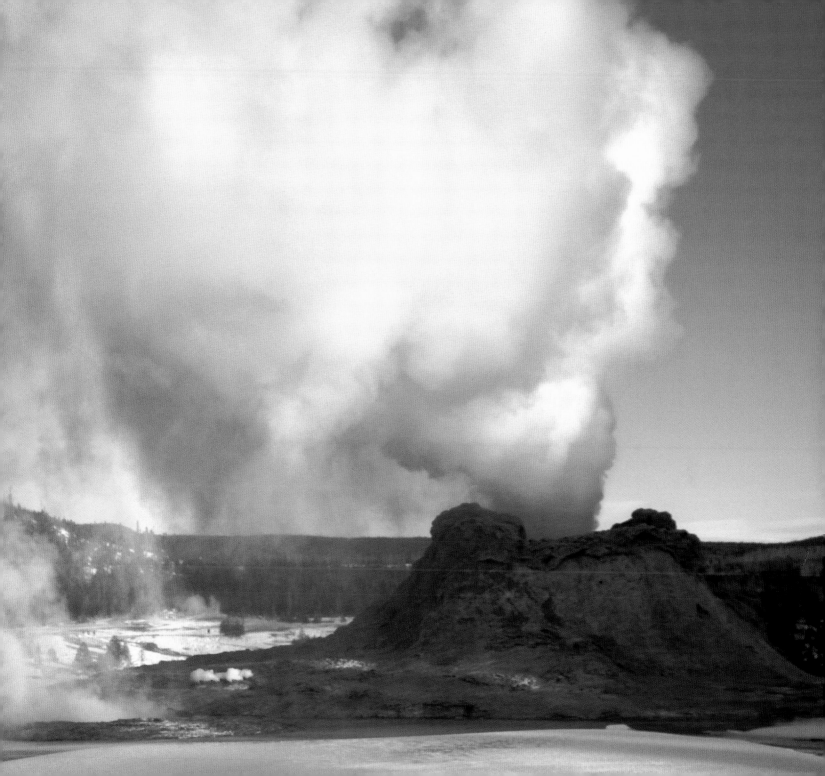

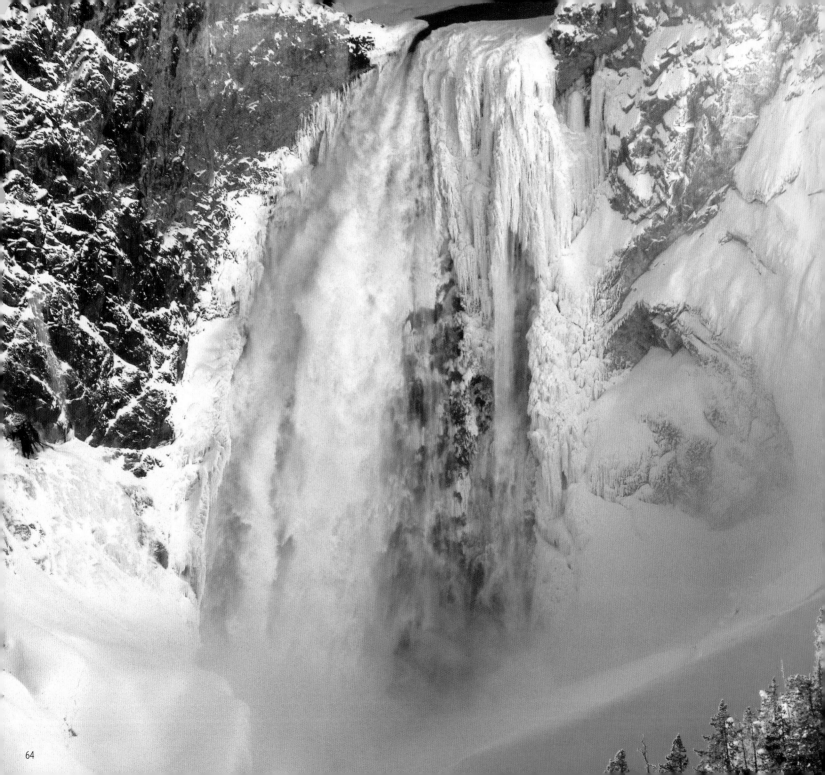

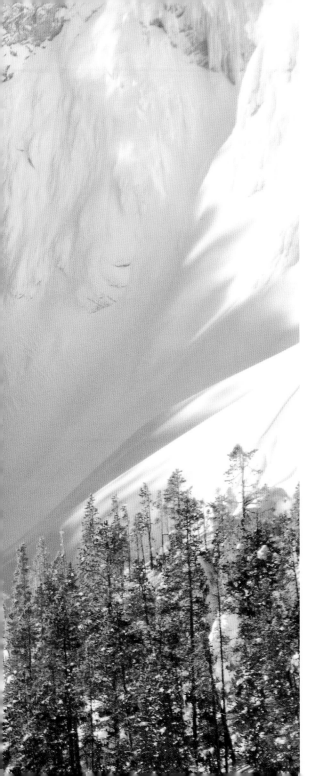

*Left:* Lower Falls of the Yellowstone River, as seen from Lookout Point in winter.

*Below:* This coyote is in hunting mode and using every sense to detect any prey under the snow.

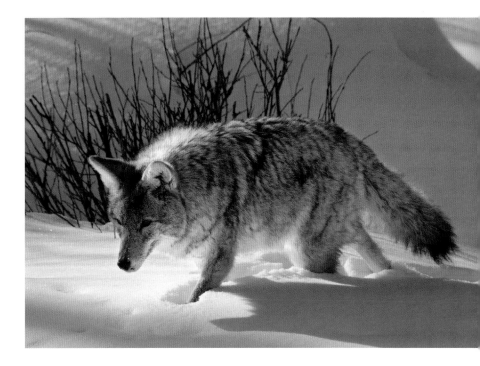

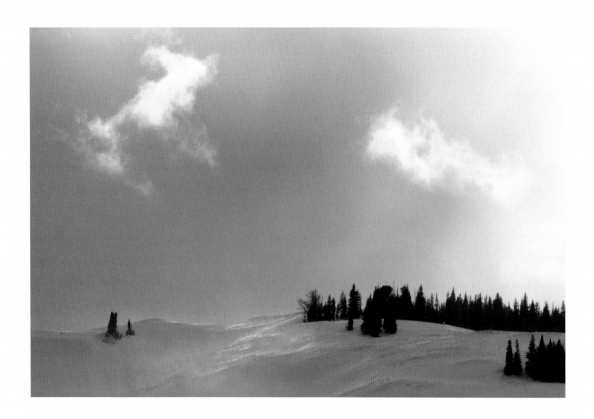

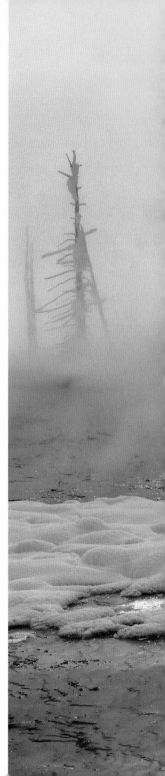

*Above:* The hanging clouds and subtle light near Slough Creek create an unforgettable three-dimensional scene.

*Right:* On a cloudy day, the snow takes on a bluish hue as seen here at Steamboat Geyser in Norris Geyser Basin.

*Far right:* Surreal scenes are found at every corner in thermal areas such as Biscuit Geyser Basin. "To see is to believe" is no cliché in Yellowstone.

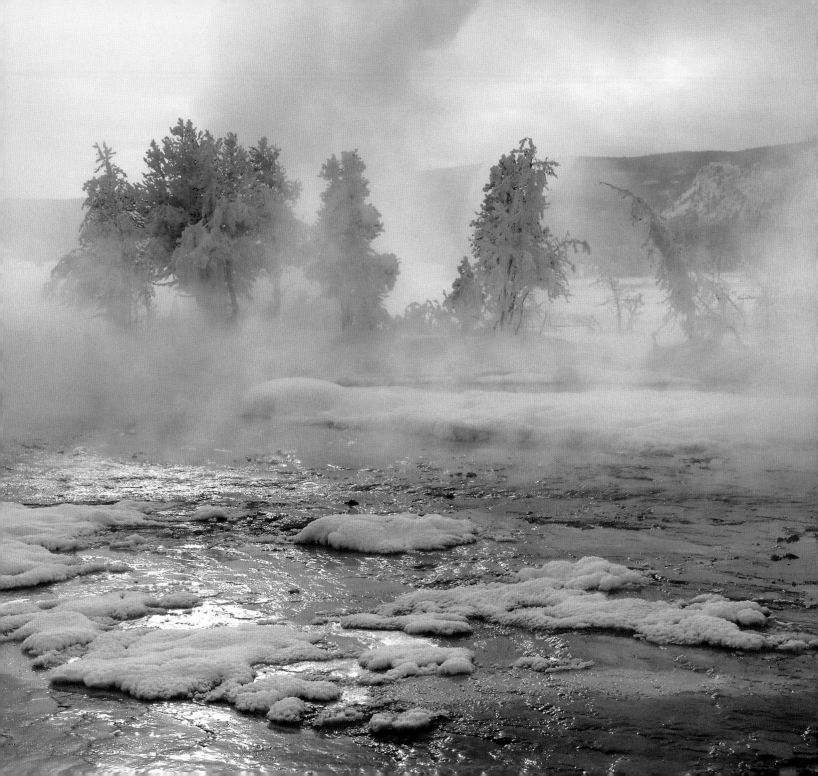

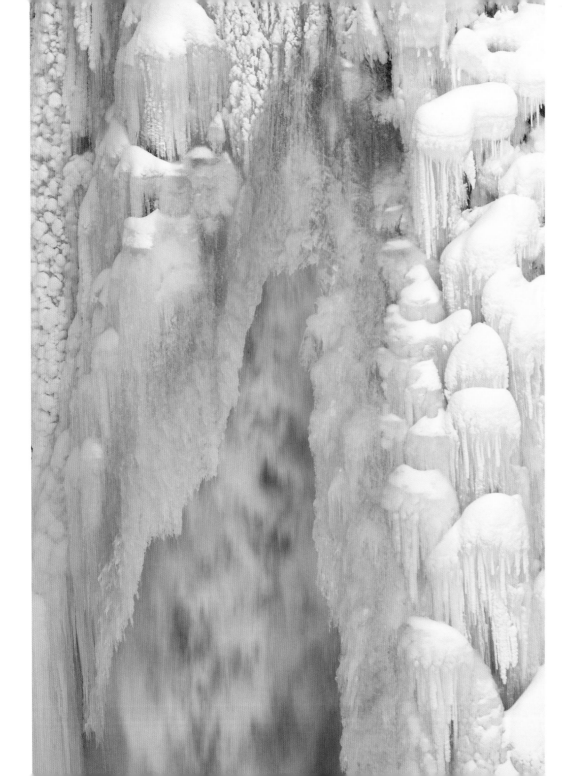

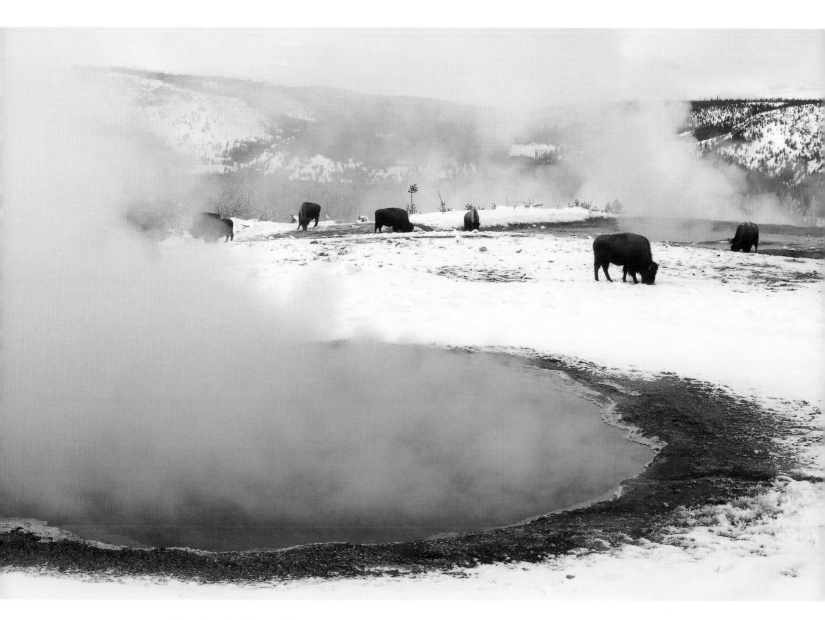

***Above:*** Thermal areas in winter are like oases in the desert, making life easier for bison and other wildlife. Bison, however, live a shorter life in these areas because their teeth wear out more quickly due to the silica and high amount of fluoride in the plants they eat.

***Facing page:*** On a relatively warm day, both falling water and ice formation on Tower Fall can be seen.

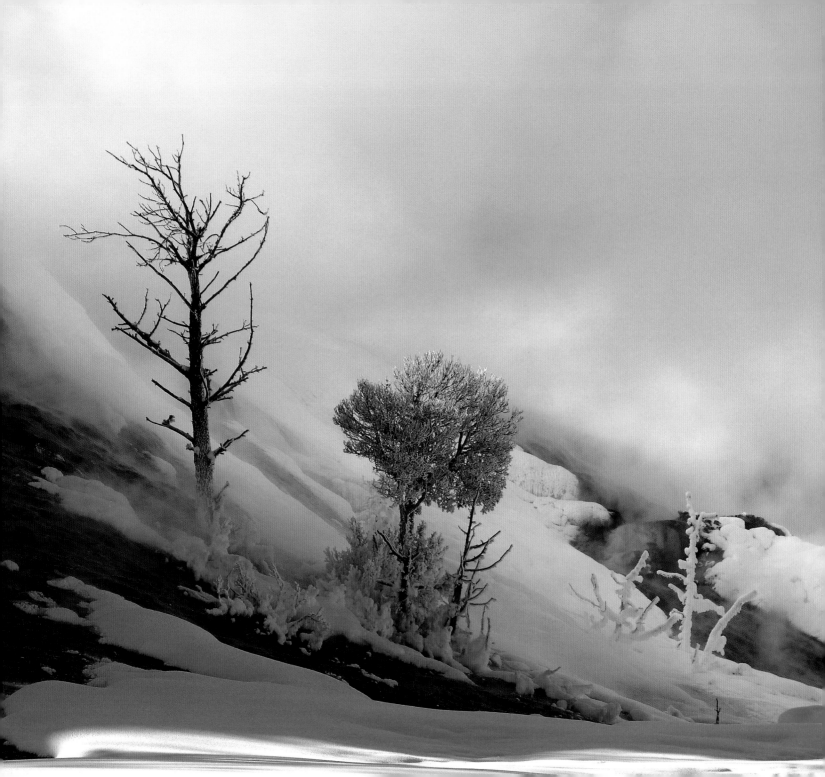

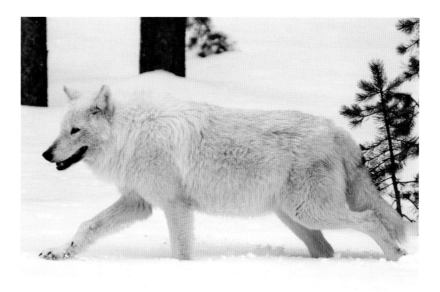

***Above:*** The alpha female of the Canyon pack was one of a few rare white wolves in the park. I took this picture of her from a snowcoach near Norris in late February 2017. Sadly, she was found mortally wounded less than two months later near the park's North Entrance and was euthanized.

***Left:*** The beauty of Yellowstone's winter is in a league of its own. Palette Spring at the Lower Terrace at Mammoth Hot Springs offers one such magical experience.

**I-TING CHIANG** lives in San Diego, California, and has been a national park traveler and photographer for more than ten years. After turning imagination into action, he continues to return to Yellowstone in winter. He has co-authored three books about national parks and regularly shares pictures on National Park Past and Present Adventures' Facebook page.

*This page:* Lodgepole pine forest near Moose Falls.